Contents

FOTOTIP 7
HAND-HELD SHUTTER SPEED RULE
1/mm = Slowest shutter speed
—See page 109.

FOTOTIP 8
EXPOSURE FACTOR FOR APERTURE COMPENSATION

Image Ratio	Exposure Factor
1:8–1:4	1.5 × or ½ *f*-stop
1:3–1:2	2 × or 1 *f*-stop
2:3–3:4	3 × or 1½ *f*-stops
1:1	4 × or 2 *f*-stops

—See page 122.

FOTOTIP 9
SOFT SHADOW RULE
Diameter of light = Light-to-subject distance.
—See page 123.

FOTOTIP 10
SUGGESTED LIST OF SUPPLEMENTARY EQUIPMENT FOR MACROPHOTOGRAPHY
—See page 127.

FOTOTIP 11
THE PICTURE STORY
The environment, the whole plant, the close-up detail.
—See page 135.

FOTOTIP 12
CROPPING SLIDES
Tape out the unessential or disturbing elements.
—See page 167.

The Essentials
of Nature
Photography

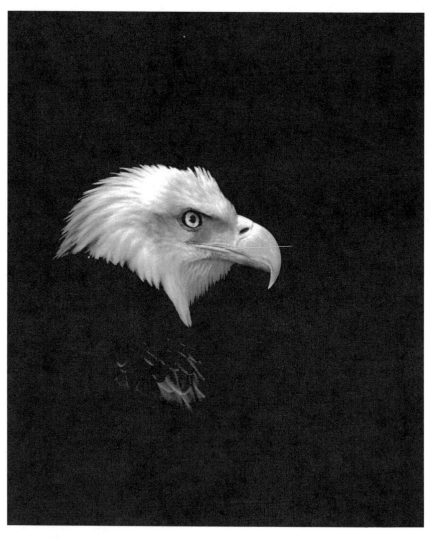

Bald Eagle *Haliaeetus leucocephalus* Injured bird in rehabilitation, Lake Buena Vista, Florida f/8 Aperture preferred.

The Essentials of Nature Photography

Milton Heiberg

The Tern Book Company
New York

ISBN 1-890309-52-4 (hardcover) 1-890309-53-2 (paper)

Library of Congress Cataloging-in-Publication Data

Heiberg, Milton.
 The essentials of nature photography / Milton Heiberg.
 p. cm.
 Includes index.
 ISBN 1-890309-52-4. -- ISBN 1-890309-53-2 (pbk.)
 1. Nature photography--Amateurs' manuals. I. Title.
TR721.H45 1997
778.9'3--dc21
 97-3592
 CIP

Printed in the United States of America by
Edwards Brothers, Inc.

First edition: March, 1997
10 9 8 7 6 5 4 3 2 1

List of Fototips

Preface

You've undoubtedly heard the expression, "Perfection is no accident." Although there may be a certain amount of "luck" connected with a good nature photograph, the "good luck" that results in an exceptionally good and rare nature photograph almost always comes to only those who have studied, practiced, and persevered. Artistic talent counts to some degree, but more important (since undeveloped and unexploited talent is almost worthless) is the love, dedication, curiosity, and persistence that you have for nature photography.

Nature photography is as broad a topic as nature itself, and as scientific and aesthetic as you are willing to let it become in your pursuit of the subject. It is too broad to be covered completely in each of its facets in a volume of this size. Therefore, where appropriate I have referred the reader to other works and sources. Also, the following chapters are designed and written to both inspire and educate you enough in nature photography to get you started. Within each chapter there is a description of the equipment necessary for the task at hand. However, some equipment and techniques are basic to all nature photography, so rather than repeat these descriptions in each chapter I have used references to Chapter 2—Some Basics, or the chapter that contains a more thorough description of the equipment and techniques needed for the task at hand. For example, many of the techniques used in Chapter 11—Flowers, Plants, and Foliage, and Chapter 12—Insects and Other Small Critters, are described in Chapter 10—Basics of Macrophotography. Wherever appropriate are Fototips—suggested lists of equipment, steps to a procedure, or encapsulated points to make a photographer's life easier.

Most of my friends are naturalists, nature photographers, or both. They are the kind of people who care about, and work toward, preserving our natural heritage and environment. Many of them are fellow members of the NYCAS (New York City Audubon Society) and have helped me a great deal in the preparation of this book. I owe a debt of gratitude to Peter Post, Gail Jankus, and Steve Feingold for reading and

bouncing ideas, Alan Levine for advice on traveling, Don Riepe for help with insect photography, Mamoji Matsumoto for use of his DaleBeam™ photography, Nadine Dumser who edited my very first book 20 years ago, and by coincidence showed up in my life again to do the final read-through on this book, Danielle Ponsolle my favorite editor and cell mate, and to my good friend and former student who is now the famous world class bird photographer Arthur Morris . . . and to the hundreds of students who attended my nature photography class over the years and have collectively given me much more than I have given them.

Who we are today depends greatly on where we were in our early years and who we were with, who impressed us most. I think that is what contributed to my finally becoming a nature photographer. I was born in 1937, which brought me through World War II as a wide-eyed little kid whose relatives and family friends of the draft age had many exciting war stories to tell. And I listened to them all.

Also at this young age I was able to observe personality traits in these men that I wouldn't be able to interpret until many years later. To make a long story short, these men went through hell and wanted to both tell their story and get back to the things they missed. In 1946 it was nature's peaceful tranquility. The excuse to be there was hunting and fishing in the Catskill and Adirondack regions of New York State. Even though they were there to "kill" wild animals, they had a deep appreciation for these animals and the environment that supported them. That generation of hunters were the people who laid the foundation for the wilderness preservation that we fight for today. But more about that later.

These men were my mentors, and I, also, became a hunter, and too good a shot for my own conscience. Killing an animal for sport with the excuse of feeding myself only went so far.

One day in my fifteenth year, I shot the noble Red Fox who stood atop of a farmer's rock fence. Under the guise of saving the farmer's chickens, I convinced myself that I was doing the right thing. It was a beautiful sight in silhouette, and a perfect target. I fired my .22 caliber rifle and the fox spun a quarter turn and fell behind the rocks. I ran to the top of the hill and found a trail of blood going into a space between the rocks that accompanied a carefully dug, well-traveled entrance to a den about five feet from the point of impact. I had more than an empty feeling.

The fox should have been dead, but he wasn't. He was down in that hole dying slowly. I caused that suffering and there was nothing I could do to undo the wrong or to end the pain. I hunted again for the love of being there, but never lifted my rifle to another living animal.

I would like to dedicate this book to the memory of
the noble Red Fox
to whom I wish I had aimed my camera

Part I

The Philosophy of Nature Photography

The urbanization part of the human evolution happened much too quickly to be complete. We must have missed or skipped something, because there is within each of us a desire to reunite ourselves with the natural world. It's evidenced in different degrees: from people who maintain house plants and aquariums, to cross-country skiers, backpackers, and mountain climbers. The great outdoors is where we came from, and going "home" to it will almost always give us a warm and rejuvenated feeling.

Think of nature photography not as an entity or hobby unto itself, but as a means of communicating this desire. Writing and speaking are verbal means of communicating both abstract and definite thoughts. Music is a very powerful means of communicating emotional feelings. Likewise, photography, as a visual art, is a means of communicating visual expression. It is a way you, the nature photographer, tell someone else exactly what you saw, whether it be in the form of a biological statement or an emotional expression of nature's beauty. Therefore, the natural subject is your concern. The camera is only your typewriter or piano; your film is only the paper on which the message or score is being written; and the image on the film is the message or emotion you are communicating. It is easier for an entomologist to learn photography and a few rules of composition than it is for a photographer to learn the habits of insects. The entomologist will recognize and get a good specimen on a perfect background, will know the best time of year to photograph it, what to include, and what to leave out of the picture. The photographer will have to learn a whole new science.

Keep the following four points in mind:

1. Love your subject more than your camera.
2. Understand your subject (i.e., animals, birds, wildflowers, etc.).
3. Be persistent. It is always rewarding in the long run, even if it is a very long run.
4. Know your tools (camera, film, etc.) so well that they become an extension of your personality.

The last two points, being persistent and knowing your tools, are true in almost every occupation. All possibility of success is gone when you give up. "Good luck" situations appear only when you have persisted in both the study and the practice of nature photography.

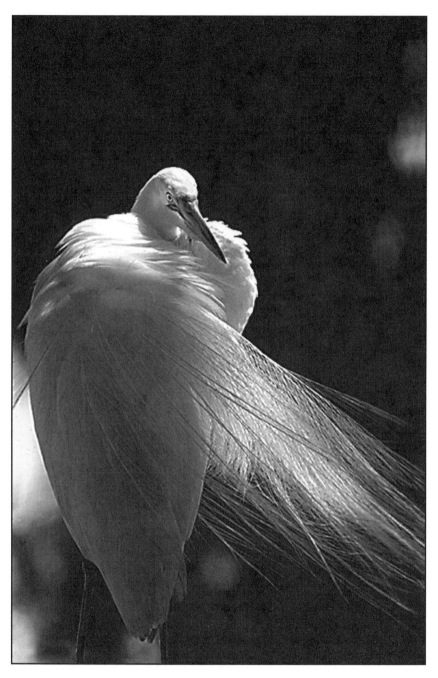

GREAT EGRET *Casmerodius albus* Lake Buena Vista, Florida

Chapter 1

Overview

Now that you've bought this book you probably expect to become a first-class, top-notch, journeyman, mensch, world class photographer by tomorrow night. Well, if you finish reading the entire volume and pass the quiz by tomorrow morning . . . you will be.

The first thing you must do is buy a camera . . . some film . . . a tripod . . . and the rest of the items mentioned in Chapters 1–12. Then get up at 5:30 AM, crank up the old Pontiac, and head for the wilds. Here, in New York City, where I live, the wilds are Jones Beach, Jamaica Bay, or if you really want to rough it, Central Park.

All kidding aside, I fully intend to give you your money's worth. I've been a photography teacher since 1981, a working wildlife photographer since 1967, and both a naturalist and a photographer since 1946. But lets get back to the camera.

Equipment Overview

It has been said that "cameras don't take pictures, photographers do." The spirit of this statement is very true, and as a photographer you may think of yourself as a maker of pictures

that come from your own inspiration in the same way as a draftsman. But unlike the draftsman who needs only a sketch pad and pencil to create images, you need a heavy bag full of very specialized equipment. Even with artistic talent, scientific knowledge, and love for your subject, getting the exceptionally good photograph in difficult situations becomes a matter of acquiring special equipment and learning the techniques of using it.

Highly specialized equipment in any field is usually purchased after the need arises, and the equipment is usually tailored or adapted to the specific need. Nature photography is no exception; a piece of photographic equipment should be purchased to fit your particular need. To prevent some serious and expensive mistakes in your purchases, you should know the direction in which you want to progress photographically, and know what options (equipment available) are open to you. Some decisions must be made about which tools to use. Each chapter in this book contains a discussion of equipment for a given topic. It would be best to read it and other up-to-date magazine articles on your specialty.

Formats can range from an 8 x 10-inch view camera (for maximum sharpness in landscape photography) to panoramic specialty cameras of any size, to 35mm cameras. However, the most popular format among nature photographers is the good old 35mm SLR (single lens reflex). The SLR fits almost any type of nature photography. It has the flexibility of viewing through the various interchangeable lenses, the compactness and lightness that allow a maximum of equipment to be carried into the field, and the quickness of movement and operation that is very often necessary in nature photography. The only two categories of nature photography that might be served better by something other than an SLR is landscape photography, which benefits from a larger film size, and underwater photography, where a standard SLR becomes cumbersome when viewing through an underwater housing (the Nikonos range finder and specialized SLR models are more convenient).

Lenses shouldn't be too much of a factor in deciding on one major system since most of the manufacturers offer high-

quality computer-designed elements (which means maximum correction for the most objectionable aberrations), so that their late models are all pretty good. Most manufacturers offer a fairly complete line of lenses. Just be sure that the one type of lens or apparatus you need for your specialty is available within the system you are considering. Photography magazines frequently run articles and comparative evaluations that will help in making your decision.

Not all equipment is available for purchase. Some must be improvised or specially made, such as some of the remote control devices (mousetraps, pressure plates, trip wires, etc.), and some equipment, while available commercially, may be home-made at a fraction of the cost, such as soundproof housings, electronic shutter release systems, blinds, reflector panels, and diffusers.

The chapters that follow contain both basic and advanced techniques in nature photography. They are necessary to know and understand and to have at your disposal when you need them. It's good to experiment with different films, lenses, and apparatus simply to discover their possibilities, and use them in some creative way. As mentioned before, it is important to become familiar with your equipment, and experimentation is the quickest way to learn.

These chapters should also give you some of the practical advice that any photographer needs, such as what to buy, how to use it, and the most efficient ways to pack camera gear for traveling and carrying in the field.

Your Reason for Photography

Photography is a medium of communication, just as is writing and speaking. As a photographer, you are the communicator and you must choose the style (format, composition, lighting, film, etc.) that in your own opinion best communicates the message to the viewer. Just as there are photographers that range from the conservative traditional to the avant garde, there are basic techniques, methods, and materials that serve each photographer. On one end of the scale we have the tripod, slow film, small aperture school of perfection, and on

the other end we have the "anything goes if it conveys your innermost emotional feelings" school of free expression; from the highly technical and scientific nature photography of Stephen Dalton, to the artistic expression of Ernst Haas in his classic book *The Creation*.

Respect for the Environment

A photographer who appreciates and studies the splendor of nature will eventually become sensitive to the forces that threaten to destroy it. Anyone today who has been a naturalist for at least ten to fifteen years has already seen too much heartbreaking destruction of the natural environment. The destruction has been on a grand scale such as bulldozing whole areas for industrial expansion or housing construction, or it has been seen in such subtle ways as noticing that certain lichens have disappeared from rock and tree bark due to polluted air. On a national and international level the first signs of breakdown in the ecosystem have been seen in studies of bird population. We see a reduction of certain warblers and other migrating species due to the destruction of rain forests in South America.

To quote the famous ornithologist Roger Tory Peterson: "Birds are indicators of the environment, a sort of ecological litmus paper. Because of their furious pace of living and high rate of metabolism, they reflect subtle changes in the environment rather quickly; they warn us of things out of balance. They send out signals when there is a deterioration of the ecosystem. It is inevitable that the intelligent person who watches birds becomes an environmentalist."

Annual bird counts across the United States during the 1950's and 1960's reported decreases in the populations of brown pelicans in the state of Louisiana, and the osprey and peregrine falcons of the Northeast. These decerases were finally linked to the use of DDT, so that in 1972 DDT was banned as a pesticide. In this case the birds warned us of a danger that would have caused serious damage to the human population. They continue to warn us about other pesticides and PCBs that affect the reproduction of animals and birds at the top of the food chain.

A more serious threat on an international level had been going unnoticed by the population at large until the mid-1980's, but was very apparent to individuals around the world who enjoyed lake fishing. While many lakes still contain fish, there are thousands of lakes in many countries that are lifeless because of acid rain. Acid rain is a product of the sulfur oxides and nitrogen oxides from the burning of fossil fuels. It does its damage by lowering the pH values of lake waters below the level that can support a healthy plant life such as algae, which in turn supports the rest of the aquatic community. The freshwater lakes of southern Scandinavia, northern Europe, southeastern Canada, nearly all of the eastern United States, as well as the western states of California, Colorado, and Washington have all been greatly affected by acid rain. Many lakes that were once abundant with fish and plant life (especially those in the Adirondack region of New York State and the thousands of wilderness lakes in southern Norway) became almost lifeless. The problem is an old one now, but it hasn't gone away. We are just getting tired of hearing about it, so we tend not to pay any more attention to it.

You may ask: "What can a nature photographer do about all this?" Well, beyond appreciating and photographing what is left, nothing much as an individual, except by doing your part in preserving and respecting the wild areas while you are there. You will also be doing your part by performing obvious precautions with campfires, not littering, and reporting thoughtless people that you see abusing wild areas. Most important as an individual, observe the simple rule that none of a photographer's methods or techniques should ever bring harm to a species or to the surrounding environment.

You can do more on a community level by joining forces with others to protect certain areas from unnecessary developmental misuse by county or state governments. Or, on a national and international level you can become an active member of organizations concerned with the environment such as the National Audubon Society or the Sierra Club, giving them your support, your involvement, your voice, and when you are able to take effective pictures of the endangered environment, your photojournalism.

The desire to photograph nature subjects is obvious. We perceive nature as beautiful, and if we have artistic leanings we want to express our feelings of its beauty by creating images that imitate or represent nature at its finest. Nature has to be documented with high-quality technical and artistically appealing photographs by as many good photographers as possible. Many natural areas may not be with us much longer. Third World countries are desperately trying to catch up, and developed countries, such as our own, are often callous to our natural heritage for the sake of further commercial development. Many years ago I mused over a superb book of photographs of Glen Canyon taken by Eliot Porter. By the time I saw that book the Glen Canyon had been filled with water and no longer existed. I had found out too late that there was such a beautiful place and I would never see it in person. If more photographers had brought back enough great photos, and inspired even more photographers, backpackers, naturalists, and the general public to visit the canyon, then perhaps there would have been enough people to effectively voice an objection to the Glen Canyon Dam project.

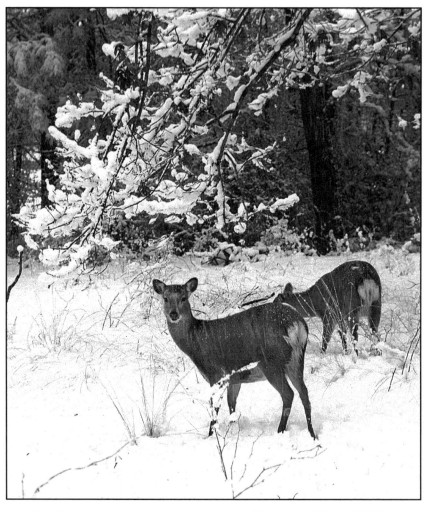

SIKA DEER *Cervus nippon* In a snowstorm at Chincoteague National Wildlife
Refuge, Assateague Island, Virginia

Chapter 2

Some Basics

During the sixteenth century in Milan, long before the invention of film, Girolamo Cardano discovered that when he placed a biconvex spectacle lens against the hole in a room-size pinhole camera, the resulting image was much sharper than with the pinhole alone. He made the hole as large as the lens and fixed the lens to it. Allowing the image to project onto a piece of paper, he moved the paper back and forth until the image was in perfect focus. Later in the same century a Venetian named Danielo Barbaro discovered that by covering the lens and leaving only a small circle (or aperture) in the middle, the image, although not as bright, was sharper still. He had discovered what is used today as the depth-of-field control, and at the same time, he discovered a control for the amount of light reaching the focal plane. Add to this the chemistry started by William Fox Talbot in the 1830s plus a few electronic odds and ends, and you have the basics of today's photography.

Cameras

Now the big question becomes: "What brand should I buy?" All of the best-selling brands of cameras are good. In today's

competitive camera market an inferior brand doesn't stand a chance. The best camera is a matter of personal preference. There are, however, subtle differences in the several brands that make some of them more adaptable to certain situations. Also, some manufacturers offer certain accessories that lend themselves nicely to nature photography, while others do not. It would be worthwhile to examine the catalogs of accessories of each of the major brands before deciding which basic camera to buy. If you already own an SLR, you may want to consider a trade-in rather than spend any more money within your present system. For instance, if you are intending to take pictures with long tele-photo lenses, you will want a camera system that allows inter-changeable viewing screens. On the standard viewing screen of older model cameras, half of a split-image or fresnel focusing area becomes blacked out with long telephoto or high magnifi-cation macro equipment.

If you intend to take close-ups of wildflowers, insects, or mushrooms, you will probably want a removable prism feature on your camera body. If so, look for a used Nikon F3, which has an easily removable prism and a choice of two magnifier attachments for waist-level viewing. This feature allows full-frame waist-level and ground-level viewing, and is preferable to a right-angle viewer attachment for a fixed-prism camera. Most of the newer models of camera bodies do not have a removable prism feature.

If your plan is to photograph flying birds or fast-running animals you should consider the most up-to-date autofocusing system as a must. As of this printing, the fastest, smoothest, and most accurate is the Canon EOS Ultrasonic system. But stay tuned to the magazine articles. Nikon is playing leapfrog with both Canon and Minolta.

Lenses

Lens Aberrations
Today's highly engineered camera lenses use the same basic prin-ciple that Cardano and Barbaro discovered so many years ago, but with much modification. One double-convex lens element

on a camera would be all that is necessary to take adequate pictures under ideal conditions such as bright sunlight with a small aperture. However, as the aperture size increases, the full diameter of the convex lens element (and its full curvature) is used. Certain mathematical qualities of light refraction (the bending of light rays through curved glass), which are incompatible with the flat plane on which the image is projected, become more pronounced. The edges of the frame are now at a different focus from the center (causing barrel distortion) and colors come through the lens at different light speeds (causing a slight prism effect called chromatic aberration). These and other types of photographically undesirable effects are called aberrations. To eliminate one type of aberration, a lens designer may add another lens element. However, in doing so, another type of aberration may be introduced or emphasized. Therefore, a third lens element, a fourth lens element, and so on, may be added until a reasonable degree of perfection is achieved.

Lens Coatings

Even though it is mathematically impossible to eliminate all aberrations entirely, today's lens design formulas, worked out quickly and inexpensively by computer, produce lenses as near to perfection as is needed by the human eye. A well-designed lens containing anywhere from five to fifteen elements has a new problem, the problem of light transmission. Most glass transmits approximately 95 percent of the incoming light and reflects approximately 5 percent. Imagine what would happen to light traveling through thirteen elements, losing 5 percent to each element. In addition, flare would be created by light bouncing back and forth between the elements. To alleviate these problems, coatings are applied in either single or multiple layers to the surfaces of the lens elements. These coatings reduce light reflection and thus, improve light transmission. In some cases, less than 1 percent of the light is lost after going through all the elements.

Hexagonal Spots and Flare

With today's improved lens coatings, flare has been reduced to a minimum. However, when the sun is shining on the lens

surface, flare will appear and a lens shade is recommended. Sometimes when the sun or a strong light source is near the edge of or just inside the frame, a strong glare comes through the viewfinder. This may not be caused so much by the light bouncing back from the lens elements as it is by light reflecting from the metal diaphragm to the back of the lens elements in front of it. This type of glare appears as a diagonal row of hexagonal spots across the entire frame—the smaller the aperture, the smaller the hexagonal spots. The number of spots is determined by the number of elements in the lens, and the shape of them is determined by the shape of the diaphragm. If there is reflection from the diaphragm (assuming a smaller than maximum aperture was chosen) it will produce a series of hexagonal or pentagonal spots across the frame. These spots can be revealed by a quick push of the depth-of-field preview button. They can be eliminated in telephoto lenses by using a lens shade and by keeping the sun out of the frame. In some cases, the spots may be difficult or even impossible to eliminate without destroying the composition. It is more difficult, however, to eliminate these spots when using wide-angle lenses. They may be minimized, however, by closing down the diaphragm as far as conditions will allow (the smaller the aperture, the smaller the hexagonal spots). Then, with a slight twist or turn of the camera, place the spots where they will not interfere with the main point of reference in your composition, or where they may even possibly add to the composition. If the situation demands that the sun be within the frame, there are two ways to eliminate the hexagonal spots. The first is to use a small aperture and place the sun directly in the center of the frame so that the spots are reflected straight back into the sun. The second is to use the maximum aperture and thus have no part of the diaphragm showing within the lens's circumference. But with this method an overall flare or haze will most likely occur.

The Definition of f/stops

The f/stop number represents the capacity of a lens to transmit light to the focal plane. As a photographer, this is the most important definition it can have to you.

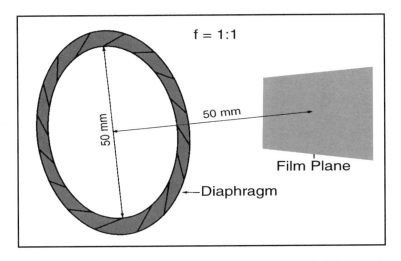

f = 1:1

50 mm

50 mm

Film Plane

Diaphragm

THE DEFINITION OF F/STOPS The f/stop ratio here is f = 1:1 or f/1. It is the ratio of the aperture to the focal length when the lens is focused on infinity. If the aperture in this diagram were reduced to 25 mm, the ratio would be 25:50, or 1:2 or f/2.

For the technically minded: To understand the universal scale of f/stops, think of a hypothetical lens in which the widest aperture is the same diameter in millimeters as the focal length of that lens. In other words, the widest aperture is f/1, and in closing down the diaphragm each aperture setting that is established will contain half the area of the preceding aperture setting. This is expressed mathematically by multiplying the ratio, or f/stop number, by $\sqrt{2}$. Thus, $\sqrt{2}$ times f/1 equals 1.4, and times 2 equals 2.8, and so on. The relationship between the f/stops may be calculated by dividing one f/stop by the other and squaring the dividend. For example, the relationship between f/2 and f/8 may be calculated as $(8/2)^2 = x$, or $(8/2)^2 = 4 \times 4 = 16$, which tells you that the light transmitted at f/2 is 16 times greater than the light transmitted at f/8.

Now, how much brighter is f/2.8 than f/4? Divide 4 by 2.8 and square the answer: $(4/2.8)^2 = (1.4286)^2 = 2$, or twice as bright. The full range of standard f/stops is as follows: f/1.0, f/1.4, f/2, f/2.8, f/4, f/5.6, f/8, f/11, f/16, f/22, f/32, f/45, and f/64. Although any f/stop number may be used in between,

such as f/3.3, f/6, almost all lens manufacturers have adopted this system and have engraved the appropriate range of these numbers on the aperture rings of their lenses. The newer auto-focus, computer-driven, auto-everything lenses and camera systems have included half/stops in both aperture and shutter speed settings. These settings appear in the liquid crystal diode (LCD) screen of the camera body because most of these lenses have no aperture rings.

Using f/stops

You must rely on the f/stop number as a standard no matter what camera or lens you are using.

A setting of f/8 on a 24mm wide-angle lens has the same capacity to transmit light as a setting of f/8 on a 200mm telephoto lens. Actually, the f/stop number is a ratio between the diameter of a given aperture and the focal length of the lens when the lens is focused at infinity. It is calculated by dividing the focal length of the lens by the diameter of the given aperture. For example, if the focal length of a lens is 100 mm and the diameter of the given aperture setting is 25 mm, the f/stop number would be 1:4 (commonly expressed as f/4, or on the lens or camera window as simply 4). If on the same lens the diaphragm were closed down so that the aperture diameter measured only 12.5 mm, the f/stop number would be 8 (expressed as f/8). If the lens were 400 mm in focal length, then f/4 would require an aperture diameter of 100 mm.

Focal Length

The focal length of a lens determines how large the subject being photographed will appear on the film. Holding the camera-to-subject distance constant, the longer the focal length the larger the image on the film. Optically speaking, the focal length of a lens is the distance from the node of emission to the focal point. The node of emission is a point within the lens on the optical axis from which the light rays going toward the focal point appear to emerge. Photographically speaking, however, the focal point and the focal plane of the camera are the same. With this in mind, long telephoto lenses are designed to be shorter than their effective focal length, and have a node of emission some-

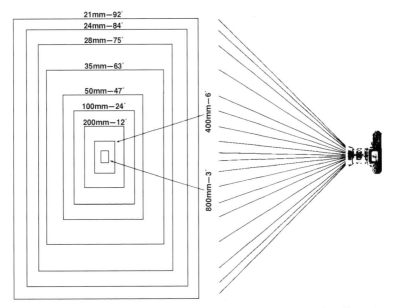

ANGLE OF VIEW The angle of view of the lens depends on its focal length. The longer the focal length, the narrower the angle of view. These angles vary from 170 degrees in a fisheye 15mm lens, to 3 degrees in a telephoto 800mm lens.

where out in front of the objective lens. On the other hand, super-wide-angle lenses are designed longer than their effective focal lengths (retro-focus lenses) so that the image can be spread more evenly over the film plane with minimum distortion. Also, these lenses have a node of emission somewhere between the rear of the lens and the focal plane. This retro-focal design also allows additional space between the focal plane and the rear elements of the lens so that the lens does not interfere with the mirror mechanism.

Perspective

Perspective refers to the way you see things from wherever you happen to be standing. Objects close to you appear large, and objects far away from you appear relatively small. Knowledge of perspective may be put to good use in creating pictures through the selection of a lens that will give you the proper angle of view for the perspective that you desire. For example, if you are relatively close to your subject and there is something in

the background that you would like to have dominate that background, such as a tree in bloom or a small building, but from your close position to the subject the background object appears dwarfed by perspective, simply move back until you see the subject smaller in relation to the background. When the desired relationship is established, this will be the camera-to-subject distance to use. Then choose the telephoto lens with the angle of view that will frame the subject as you envisioned it. If you want the subject to appear much larger than the object in the background, simply move in closer until with your eye you establish the relationship of sizes between the background and the subject and use a wide-angle lens. Keep in mind that wide-angle lenses emphasize distances through perspective, and telephoto lenses minimize or foreshorten distances.

Depth of Field

Depth of field is defined as the range of distance in front of and behind the subject that falls within reasonably good focus when the subject itself is in perfect focus. It is affected by three independent variables: (1) the size of the aperture, (2) the focal length of the lens, and (3) the distance from the camera to the subject.

Depth of Field—Aperture

With respect to the aperture, the depth of field increases as the size of the aperture decreases. Suppose you are shooting a subject 3.1 m (10 ft) away with film rated at ISO (International Standards Organization) 100 with a normal 50mm lens at a shutter speed of 1/1000 sec and the aperture set at f/2.8. The setting of f/2.8 allows a depth of field ranging from less than a foot in front of the subject to a little more than a foot behind the subject. All of the remaining foreground and background are out of focus. If, however, you close down the aperture to f/8 (under the same lighting conditions the shutter speed would be 1/125 sec), the depth of field would increase to a range of approximately 0.9 m (3 ft) in front of the subject to 3.1 m (10 ft) behind the subject. And if you close the aperture down to f/16 (the shutter speed would be 1/30 sec), the depth of field would increase approximately 1.5 m (5 ft) in front of the subject, back

to infinity so that almost all of the foreground and background would be in reasonably good focus. A quick press of the preview button before taking a picture will manually close down the aperture to the pre-designated f/stop, thus allowing you to visually check your depth of field. Sometimes, when pre-designating a small aperture you may be completely unaware of an undesirable background that will come into focus when you release the shutter and the diaphragm closes down automatically. Keep in mind that you are viewing your subject with the lens at its widest aperture and thus its shortest depth of field. This is especially important when using telephoto lenses, or even when using a normal lens when the subject is close to the camera.

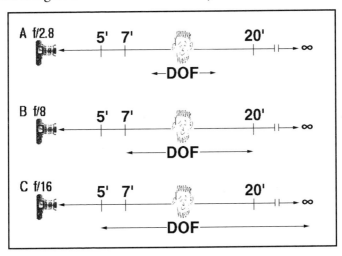

DEPTH OF FIELD—APERTURE The subject in this illustration is 10 ft from the camera with a 50mm lens attached.

Depth of Field—Focal Length
The focal length of a lens is the second of the three determinants of depth of field. That is, holding the aperture size and subject-to-camera distance as constants and allowing the focal length to be the variable, the longer the focal length, the shorter the depth of field. To illustrate, place the subject 3.7 m (12 ft) away from the camera, and set the aperture at f/5.6 on each of two lenses. A wide-angle lens such as a 24mm lens will have depth of field ranging from approximately 1.5 m (5 ft) in front

of the subject to 26.8 m (88 ft) behind the subject, whereas a medium telephoto lens such as a 135mm lens will have a depth of field ranging from approximately 20.3 cm (8 in.) in front of the subject to 22.9 cm (9 in.) behind the subject (hardly any depth of field at all). Be aware, however, that if you keep the image size constant by moving closer to the subject with a shorter focal length lens, the depth of field will be the same in both lenses (assuming the same corresponding f/stops).

Depth of Field—Camera-to-Subject Distance

The third determinant of depth of field is the distance between the camera and the subject. The greater the distance, the greater the depth of field. It is also worth mentioning that the depth of field is always greater behind the subject than in front of the subject. The distance factor holds true for all lenses. For the purpose of illustration, consider a 35mm f/2.8 lens with the aperture set at f/5.6. A camera-to-subject distance of 0.5 m ($1\frac{1}{2}$ ft) gives a depth of field of 2.1 cm ($\frac{13}{16}$ in.) in front of the subject to 2.4 cm (1 in.) behind the subject. With the subject in focus at 1.8 m (6 ft), depth of field would range from 0.4 m ($1\frac{1}{3}$ ft) in front of the subject to 0.6 m (2 ft) behind. Focusing the subject at 9.1 m (30 ft) gives a depth of field of 5.2 m (17 ft 1 in.) in front of the subject and a depth of field to infinity in back.

It is by no means necessary to memorize any of these numbers, nor is it necessary to carry any scales around with you while taking pictures. It is a good idea, however, to learn how these three variables (aperture setting, focal length, and camera-to-subject distance) interplay in determining the depth of field to intelligently predict and plan your pictures.

Depth of Field—Previewing

Depth of field previewing is an essential part of composing almost all still photographs. Most top-of-the-line camera bodies have a depth of field preview feature. The older manual focus cameras have a button that releases the aperture mechanism so that it will close down to the f/stop you have the lens set at. The newer autofocus systems accomplish the same thing electronically. Before buying a new or used camera body, make sure that

(1) it has a depth of field preview feature, and (2) it is easily accessible and comfortable to use. And develop the habit of using it.

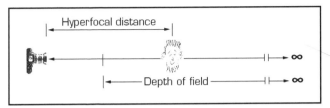

Hyperfocal Distance

The hyperfocal distance is the distance from the lens to the point of perfect focus when the depth of field extends beyond that point to infinity and to a point midway between that point and the lens. Because the hyperfocal distance is a product of depth of field and depth of field changes with aperture and focal length, the smaller the aperture, the closer the hyperfocal distance; therefore, the closer the entry point of depth of field is to the camera. Also, the wider the angle of view, the closer the entry point is to the camera, always continuing to infinity.

Before 35mm autofocus systems became available, photojournalists used the principle of hyperfocal distance when they were on the run getting action pictures and there was no time to focus accurately. The older type lenses had depth of field

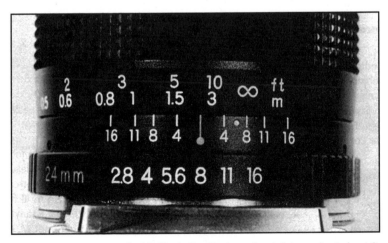

THE HYPERFOCAL SETTING In this illustration the hyperfocal distance is at about 8 ft. The depth of field is from about 4 ft to infinity.

scales (a series of f/stop numbers on each side of the reference point) engraved on the lens, as well as a distance scale in both feet and meters engraved on the focusing ring (see illustration). The rushed photojournalist would set the infinity mark on the focusing ring at the f/stop mark for the intended f/stop—usually f/8. Using a 35mm lens on a 35mm SLR this setting rendered a depth of field from approximately 3.7 m (12 ft) to infinity, with the point of perfect focus at 7.3 m (24 ft). Using ISO 125 film (the good-old Kodak Plus-X film) and a shutter speed of 1/500 sec, these photographers would be ready for any kind of action. They could shoot from the hip or hold the camera high above the crowd, then aim and shoot. These were commonly called Hail Mary shots. This was also the principle used on most simple box cameras that had no variable f/stop or shutter speed settings.

The principle and application of hyperfocal distance is no longer as important to know since we now have autofocus systems; however, it is good to learn if you are in a situation where the light is too dim for autofocusing on a running animal, or if you are using a camera body without a depth of field previewer.

Films

Digital cameras are on the market and are quickly being accepted by professional photojournalists, but as of this printing their expense, size, weight, and end result are not up to the quality standards of today's fine-grained films. I'm all for digital photography, but every photo in this book was shot on film, then scanned and/or separated using digital technology. Until the quality of digital photography reaches the quality of films, the film industry will continue to produce 35mm cassettes, and I'll continue to use them.

Much of the splendor of nature is in color, so that one thinks of nature photography as being color photography. This does not rule out black and white nature photography by any means. Many very beautiful nature photographs have been done in black and white. Consider the work of Ansel Adams. The vast majority of nature photography, however, is done in color.

The ideal color film for all situations has not yet been invented and probably never will be. Fine-grained films are too slow for action and fast films are too grainy. When selecting a color film you must choose between fine grain and high speed, or compromise by choosing a medium-speed, medium-grain film. Your film should fit the situation (e.g., the subtle color of a wildflower would be best photographed on a film as fine-grained as possible). On the other hand, a lion racing in pursuit of a zebra would be a big blur on a slow film, so that fine grain must be sacrificed for a high-speed film just to be able to stop the action. A film speed of ISO 64 or 100 will stop some slow-moving action and still maintain as fine a grain as possible for animal behavioral studies or birds at the nest. Your best approach is to experiment with a variety of films to see which ones fit your needs. This may be narrowed down to just one type of film for your specialty or as many as necessary. The idea is to use as few film types as possible so that (1) you don't need to stock and carry a large assortment, and (2) you learn the characteristics of each film that you use.

Although the overwhelming majority of nature photographers use color slide film (that's what publishers buy and make color separations from) there is an advantage to using color negative film. There is less apparent grain in the higher speed color negative films. If your ultimate goal is to make large display prints, there is nothing better to work with than an original color negative.

There is one important fact to keep in mind when working with color negative films. An underexposed negative cannot be reasonably salvaged. The emulsion is too thin and the print will be flat and washed out. But a slightly overexposed (therefore, denser) negative may simply pick up some additional contrast. This is the opposite of color slide films, where an underexposure adds density to the emulsion and can be salvaged by making an overexposed duplicate slide. An overexposed original color slide has insufficient detail to copy from.

The accompanying film tables will give you an idea of some of the films that are available. For general use, as a nature photographer, you can usually get by with two types of daylight

35MM COLOR SLIDE FILMS

FILM	CODE	ISO	TYPE	SATURATION
Kodachrome 25 Pro	PKM	25	Daylight	Neutral/Enhanced
Kodachrome 25	KM	25	Daylight	Neutral/Enhanced
Kodachrome 40 Pro	KPA	40	Tungsten	Neutral/Accurate
Ektachrome Elite 50	EA	50	Daylight	Neutral/Enhanced
Velvia Pro	RVP	50	Daylight	Warm/Enhanced
Agfachrome 50 Plat. Pro	RS 50 +	50	Daylight	Neutral/Accurate
Ektachrome 64X Pro	EPX	64	Daylight	Warm/Enhanced
Ektachrome 64T Pro	EPY	64	Tungsten	Neutral/Accurate
Ektachrome 64 Pro	EPR	64	Daylight	Neutral/Enhanced
Kodachrome 64 Pro	PKR	64	Daylight	Neutral/Enhanced
Kodachrome 64	KR	64	Daylight	Neutral/Enhanced
Fujichrome 64 Pro Tungsten	RTP	64	Tungsten	Neutral/Accurate
E. Lumiere 100X Pro	LPZ	100	Daylight	Warm/Enhanced
E. Lumiere 100 Pro	LPP	100	Daylight	Neutral/Enhanced
Ektachrome Elite 100	EB	100	Daylight	Neutral/Enhanced
Ektachrome 100X Pro	EPZ	100	Daylight	Warm/Enhanced
Ektachrome 100 Pro	EPN	100	Daylight	Neutral/Accurate
Ektachrome 100 Plus Pro	EPP	100	Daylight	Neutral/Enhanced
Ektachrome E100S	E100S	100	Daylight	Neutral/Enhanced
Ektachrome E100SW	E100SW	100	Daylight	Warm/Enhanced
Fujichrome Sensia 100	RD	100	Daylight	Neutral/Accurate
Fujichrome Provia 100 Pro	RDPII	100	Daylight	Neutral/Enhanced
Fujichrome 100 Pro	RDP	100	Daylight	Neutral/Accurate
Agfachrome 100 Plat. Pro	RS 100 +	100	Daylight	Neutral/Accurate
Ektachrome 160T Pro	EPT	160	Tungsten	Neutral/Enhanced
Ektachrome 160T	ET	160	Tungsten	Neutral/Accurate
Ektachrome Elite 200	ED	200	Daylight	Neutral/Enhanced
Ektachrome 200 Pro	EPD	200	Daylight	Neutral/Enhanced
Kodachrome 200 Pro	PKL	200	Daylight	Neutral/Enhanced
Kodachrome 200	KL	200	Daylight	Neutral/Enhanced
Fujichrome Sensia 200	RM	200	Daylight	Neutral/Accurate
Agfachrome 200 Plat. Pro	RS 200 +	200	Daylight	Neutral/Accurate
Ektachrome 320T Pro	EPJ	320	Tungsten	Neutral/Enhanced
Ektachrome Elite 400	EL	400	Daylight	Neutral/Enhanced
Ektachrome 400X Pro	EPL	400	Daylight	Warm/Enhanced
Fujichrome Sensia 400	RH	400	Daylight	Neutral/Accurate
Fujichrome Provia 400 Pro	RHP	400	Daylight	Neutral/Accurate
Agfachrome 1000 Plat. Pro RS	1000 +	1000	Daylight	Neutral/Accurate
Ektachrome P1600 Pro	EPH	1600	Daylight	Neutral/Accurate
Fujichrome 1600 Pro	RSP	1600	Daylight	Neutral/Accurate

35MM COLOR NEGATIVE FILMS

FILM	CODE	ISO	TYPE	CONTRAST
Kodak Ektar 25 Pro	PHR	25	Daylight	High
Kodak Royal Gold 25	RZ	25	Daylight	High
Agfa Triade Ultra 50	Ultra	50	Daylight	High
Kodak Pro 100	PRN	100	Daylight	High
Kodak Royal Gold 100	RA	100	Daylight	High
Kodak Gold Plus 100	GA	100	Daylight	High
K. Ektapress Plus 100 Pro	PJA	100	Daylight	High
K. Vericolor II Pro Type L	VPL	100	Daylight	High
Fujicolor Super G 100	CN	100	Daylight	Normal
Fujicolor Reala 100	CS	100	Daylight	High
Agfa Triade Optima 125	Optima	125	Daylight	Normal
Ektacolor 160 Pro	GPF	160	Daylight	Normal
K. Vericolor III Pro Type S	VPS	160	Daylight	High
Fujicolor NPS 160 Pro	NPS	160	Daylight	Low
Fujicolor NPL 160 Pro	NPL	160	Tungsten	Low
Agfa Triade Portrait 160 Pro	160	160	Daylight	Low
Kodak Super Gold 200	GB	200	Daylight	High
K. Ektapress Plus 200 Pro	PJZ	200	Daylight	Normal
Fujicolor Super G 200	CA	200	Daylight	Normal
Agfa Triade Optima 200	Optima	200	Daylight	Normal
Kodak Pro 400 MC	PMC	400	Daylight	Normal
Kodak Pro 400	PPF	400	Daylight	High
Kodak Royal Gold 400	RC	400	Daylight	High
Kodak Gold Ultra 400	GC	400	Daylight	High
K. Ektapress Plus 400 Pro	PJB	400	Daylight	Normal
Fujicolor Super G 400	CH	400	Daylight	Normal
Agfa Triade Optima 400	Optima	400	Daylight	Normal
Fujicolor Super G 800	CZ	800	Daylight	Normal
Kodak Royal Gold 1000	RF	1000	Daylight	High
Agfa XRS Platinum 1000	XRS	1000	Daylight	Normal
K. Ektapress Plus 1600 Pro	PJC	1600	Daylight	Normal
Fujicolor Super G 1600	CU	1600	Daylight	Normal

GENERAL PURPOSE B&W FILMS

FILM	ISO	COMMENTS
Agfapan 25 (APX25)	25	
Ilford PanF Plus	50	
Kodak T-Max 100 (TMX)	100	"Tabular" grain
Kodak Ektapan	100	
Ilford Delta 100	100	"core shell" grain
Agfapan APX 100 (APX 100)	100	
Kodak Plus-X (PX)	125	
Kodak Verichrome Pan (VP)	125	
Ilford FP4 Plus	125	

film: a slow fine-grained film (such as Kodachrome 64 or Velvia 50), and a high-speed film (such as Kodachrome 200) for super-telephoto f/11 pictures or action shots requiring fast shutter speeds, and occasionally a few rolls of indoor film (such as Ektachrome 160 Tungsten) for available light shooting in a zoo or an aquarium that uses tungsten light.

If your preference is black and white photography you will probably get along with one film quite easily. Today's black and white films have been perfected so that pictures taken with a high speed film such as T-Max 400 have very little grain. For super-fine-grained pictures with excellent resolution, and subtle tones all the way across the gray scale, use a slower black and white film such as T-Max 100.

If you are carrying a limited assortment of film and you need a film that is faster than your fastest film, then you may "push" your film at least one stop. Some black and white films can be pushed up to two and one-half stops using longer developing times. To push film one f/stop more exposure, simply set the ISO dial on your meter to a number double that of your film's ISO rating. To push two f/stops, double it again. In the lab, developing time will have to be increased to compensate for what is, in effect, an underexposure. Black and white films and most color films may be pushed at least one stop and still maintain good quality.

Filters

Most daylight color films are designed to be used in bright sunlight. They may also work well in shade and certainly will record the vivid colors of a sunset. However, when used in less than ideal conditions, film will exaggerate the color that our eyes see (i.e., on a "blue" day, dreary and overcast, the film will record more of a blue cast over the whole picture than you where conscious of when you took the picture). The remedy: use an 81A filter to restore some of the warm tones. At the other extreme of color, the dramatic but overly warm light of a sunset reflecting from a subject may be corrected somewhat and still retain pleasing color with the use of an 82A filter. The 81A filter requires an additional one-half stop of exposure to compensate for its

density. The 82A filter needs one-third stop additional exposure. As with all filters, if you are using the camera's metering system, this adjustment is already done and is of little concern while making exposures.

A polarizing filter may be used in landscape photography to eliminate haze in the distance, darken a blue sky, or remove the glare from a water surface. It is fully effective when the camera is pointed in a direction ninety degrees from the direction of the light source (the sun). This means, theoretically, when the sun is directly overhead all of the horizon may be affected by the polarizing filter. The oblique light of early morning or late afternoon limits the effectiveness of the polarizing filter to two directions north and south.

One very important filter for landscape photography should not be overlooked. The graduated neutral density filter. Often a beautiful landscape has a very bright sky and a subdued foreground; especially water reflections and sunrises or sunsets where the foreground is in a shadow area. The Tiffen "P" color grad number ND .6 is good for these situations. An extremely high-contrast situation may demand a number ND .9. Graduated filters are also available in blue and amber.

With black and white photography a given color in nature may be made to appear darker in the final print by photographing the scene through a filter of a complimentary color. For example, a blue sky can be made to appear dark gray or black by photographing it through an orange or a red filter, thus emphasizing cloud formations. At the other end of the scale, a deep blue (C5) filter will intensify haze and help create a high-key, misty mood.

Exposure

It is important to understand the principles of exposure to get the most from your camera's controls. Even when taking pictures using your camera's AE (automatic exposure) mode you should know what is going on. Even though the balance of shutter speed and aperture are automatically and theoretically correct, the combinations that make that balance may not be the best for your particular situation.

Probably the most graphic way to explain exposure is by the water faucet and bucket analogy. Think of the bucket as the film. It must be filled to the brim, just as our film must be filled with light for a proper exposure. It cannot overflow or we will have an overexposure, and too little light will not fill it enough and it will be underexposed. A fast film is like a small bucket. It takes very little light to fill it for a proper exposure. A slow film or large bucket takes a lot more. Now the faucet has two controls to fill the bucket. The length of time that the faucet remains open (shutter speed) and the degree to which the faucet is opened (aperture or f/stop). To fill the bucket, we may open the faucet a little and let the water trickle in for a long time until the bucket is full. If we want to fill the bucket faster, let us say, in one-half the time, we must double the size of the faucet opening. In the same manner, for any given correct exposure combination, if the shutter speed is halved, the aperture size must be doubled (opened one f/stop) to compensate and keep the exposure correct.

In the event you wanted to stop a fast running animal, you would opt for a fast shutter speed and open the aperture accordingly to compensate. If, on the other hand, you wanted maximum depth of field, then you would want as small an aperture as your lens would allow and let the light trickle in with a slow shutter speed.

The Correct Exposure

What is a correct exposure? The answer to that question is very subjective. It is whatever exposure that results in the image you had in mind. It can also be defined as the metered exposure or the exposure that the *meter* had in mind. If you had in mind the rich color of a wildflower against a dark shadow area, and the resulting image was a pale, washed out flower on a medium gray background, then you got what the meter had in mind. For *your* correct exposure, in this case, you would meter the highlighted area—the wildflower. On the other hand, if you were photographing an animal backlighted by the sun, you would get a silhouette with a richly exposed background and highlight of the rim-lighted fur. Here you would want to meter the shadow side of the animal for a detailed correct exposure, or darken the shadow side by $\frac{1}{2}$ f/stop for a more natural looking image.

Exposure Meters

Through-the-Lens (TTL) Meters

Almost all cameras sold today (new and used) have some kind of TTL metering system. Most have AE systems where the meter sets the aperture and/or the shutter speed automatically. There are several types of AE systems.

1. Aperture preferred: You set the aperture and the system sets the shutter speed accordingly for a correct exposure.
2. Shutter speed preferred: You set the shutter speed and the system sets the aperture.
3. Programmed exposure: The system sets both shutter speed and aperture, taking everything that it senses into account such as fill-in flash, motion of a panning camera (sets a faster shutter speed), or any number of other features depending on the features of the camera model.

Some of these AE metering systems offer a choice of metering methods such as:

1. Averaging (which considers the entire frame)
2. Center-weighted averaging
3. Spot metering
4. Evaluative (matrix)

Although these systems have been known to falter and should be checked periodically, they are usually quite accurate. There are situations, however, such as darker than usual subjects, or shadow areas within a subject, that can affect or fool the meter and give you an incorrect exposure. Therefore, it is advisable to bracket your exposures (i.e., make at least two additional exposures: one with $\frac{1}{2}$ f/stop more exposure and one with $\frac{1}{2}$ f/stop less exposure. Bracketing with an AE metering system is done with an exposure compensation dial. Check your camera's instruction manual for details of your system. Some of the older AE systems on the less expensive cameras did not feature an exposure compensation dial. In these cases you must change the ISO setting to a faster or slower film speed and remember to reset it correctly when finished.

After you have used an in-camera metering system for a while you may feel that you can predict the resulting image on film. You may tend to trust its accuracy and rely on the system in all situations because most of your pictures will be metered within the normal range of daylight exposures. **Beware:** Many metering systems become inaccurate in very low light and extremely bright light, sometimes by as much as two or more f/stops. Also, I've found both the Canon and Nikon systems to be inconsistent in the amount of correction needed, not just between the companies, but between individual models within one company. The answer to this problem is to test and bracket your exposures accordingly until you get to know your own metering system very well, and then keep the habit of bracketing. If you have any doubts about the meter's accuracy bring it into a camera repair service for a calibration check.

Hand-Held Meters

Your surest path to a correct exposure is to use a light meter. If you don't have one built into your camera, then you should use a hand-held meter. Make sure the meter is reading only the light reflected from the subject area and none of the background area, especially if the background is in the shade. There are several ways to take a light reading. The most obvious is to walk up to the subject and read the light being reflected from it. If your subject happens to be a sunbathing rattlesnake, then leave it alone and take a reading from the light being reflected from a standard 18 percent gray panel (a gray card sold by Kodak that reflects 18% of the light shining on it). If you don't have one with you, then use the palm of your hand. Be sure the card or your hand is being held at the same angle to the sun as your subject. Filling the metered area with this type of controlled reflected light avoids the pitfalls of backlighted situations or shaded backgrounds that fool the meter.

Incident Light Meters

A good method to use if you have a wide range of tones and you are unsure which will dominate the meter is to take an incident reading. Many hand-held meters are equipped with a slide attachment that looks something like a white translucent bubble

or hemisphere that is placed over the light-sensitive cell. Some meters are designed to take only incident readings. Here the meter is held in the general vicinity of the subject (with artificial light at the same distance from the main light as the subject), and a reading is taken from the source of light.

Emergency Metering

When all else fails and you refuse to believe in your metering system for any reason, set your camera manually using the Sunny 16 rule of exposure as described in the Fototip 1 below. This formula should also be used to frequently check your metering system (to keep it honest so to speak) even when it appears to be working well.

FOTOTIP 1

SUNNY 16 RULE

In the event of meter failure, there is a formula that may easily be memorized to give you a correct exposure for any type of daylight film being used outdoors. It is a good point of reference to work from that covers most of the common lighting situations:

1/ISO = SHUTTER SPEED AT F/16
IN MID-DAY BRIGHT SUN

Example: If you are using a film with an ISO rating of 64, your aperture in bright sun is given at f/16 and your shutter speed would be 1/64 sec, or the nearest setting on the shutter speed dial, which is 1/60 sec. Also with this formula, if you were using a film of ISO 400, your nearest setting would be 1/500 sec. Naturally, any equivalent combination of shutter speed and aperture will do as well, and would often be preferable to the exact formula. This formula is a starting point that assumes subjects of average density. It should be adjusted according to the following list of situations:

1. Light subject: Decrease exposure $\frac{1}{2}$ to 1 f/stop.
2. Dark subject: Increase exposure $\frac{1}{2}$ to 1 f/stop.
3. Backlighted subject: Increase exposure 1 to $1\frac{1}{2}$ f/stop.
4. Open shadow area (much light reflecting in): Increase exposure 1 f/stop.
5. Normal shadow areas: Increase exposure 2 to 3 f/stops.
6. Light overcast: Increase exposure $\frac{1}{2}$ to 1 f/stop.
7. Heavy overcast: Increase exposure 2 to 3 f/stops.

In all cases, bracket your exposures to ensure good results.

This good sport collapsed ten feet later.

Chapter 3

Accessories

It's not just a photograph. It's a way of life. It's not just a camera. It's a truckload of accessories. After the first camera body and several lenses, you will need a special bag to carry it all. This bag will need some extra room for a flash unit or two, reflectors, a bean bag support, an umbrella, two straps on the outside to attach a moderately sized tripod . . . and the list goes on. And if you go as far in photography as I have, you will need a large assistant to carry the bag. This chapter describes some of the more basic accessories necessary to get started for serious nature photography. Additional equipment is discussed in the later chapters within the various specialty situations.

Camera Supports

Quite often you may hear a photographer boast about being able to use long telephoto lenses hand-held at slow shutter speeds. While it can be done in certain situations where there is something available on which to brace the camera, such as the crotch of a tree or rocks, most often the hand-held pictures show at least a slight vibration softness-blur. This softness, if only slight, is not always apparent when projected on a screen, but is very

apparent to a critical photo buyer with a high-magnification loupe. Before deciding on hand-holding a long lenses, ask to see some of the pictures taken by the above mentioned steady-handed photographer, and decide if you would accept that photographer's standards of sharpness. A good rule to follow is: Wherever you can use a tripod (or other camera support), use it.

The Tripod

With almost every other piece of camera equipment that you have to carry into the field, minimum size and weight is desirable. With a tripod, however, the minimum will probably be substandard. A small flimsy tripod is usually worse than none at all. Among the many tripods that I've owned, I have used one moderately heavy Gitzo Studex tripod for more than twenty years. It has taken a beating, but still works well and holds a 400mm lens and camera body rock steady especially with a Kirk leg support added (see Chapter 9—Bird Photography). The Gitzo is expensive, but it has lasted the life of ten less expensive tripods. Be sure the one you buy supports your camera with its heaviest lens. Test it in the store (with equipment on it of equal weight and focal length) by slightly shaking it as you look through the viewfinder. If the motion continues immediately after you've stopped shaking it, try something more sturdy. For techniques on using long lenses on a tripod and other support methods, see Chapter 9—Bird Photography.

Tripod Heads

Almost as important as the sturdiness of the tripod itself is the quality of the tripod head. This accessory may either make life a pleasure with its ease of use, or it could become the weakest link in the chain. There are a number of good tripod heads on the market. If your tripod is carrying a heavy load such as a 600mm or 800mm telephoto lens, then there are only a few that are worthwhile using. Among the most popular are the Studio Ball, the Arca Swiss B1, or B1G Monoball (the "G" stands for giant—especially good with the heavy 600mm or larger lenses), the Arca B2, and the Wimberly. The former two (true ball heads) allow complete freedom of movement with just one control knob to tighten once you have positioned your subject in the frame.

The latter two items (Arca B2 and Wimberly) are both very smooth and comfortable to work with, but they require the tripod to be 100 percent level. Since most large tripods feature a built-in level, this might not be a major problem *if* you have time to level off the tripod each time you spot a running elk, fox, caribou, of golden eagle in flight. I favor the Arca B-1G.

Other Supports

Where a tripod is impractical, such as with birds in flight or fast-moving animals, a gun stock or shoulder brace will help steady the camera. In tight corners or on ledges where a tripod can't be opened, a monopod may come in handy, but remember they steady the camera in a vertical direction only. Back-and-forth, side-to-side motion is still a big problem. A tripod with the legs folded together is as good in tight situations. For macrophotography, a small tabletop tripod, or a "C" clamp with a tripod head should be used together with a focusing rail (see Chapter 10—Basics of Macrophotography).

Flash Units

Electronic flash units are an important light source for nature photography, especially when photographing birds at the nest, or insects and wildflowers close-up. Since the flash units must be carried into the field, they should be small and as light as possible without giving up some of the important features such as "automatic cutoff," or "dedicated" feature. The smallest and cheapest units with no features other than a single given power can be very handy, and perhaps it would be a good idea to carry one in your camera bag as an emergency backup. However, they are usually designed as low-power, low-guide-number, non-automatic units that need calculations for each exposure. The automatic units are slightly larger and more expensive, but automatically control the duration of flash by reading back the reflected light. At the precise instant that "enough" light has been reflected, the "electronic eye" cuts off the flash. A step beyond the automatic units are the TTL units called "dedicated" units. These units control flash duration in the same way as the above-mentioned automatic units, except that

the reflected light is read back through the camera lens. The advantage of the TTL unit is that there is no error of reading light reflected from an object closer than the one being photographed. The unit reads reflected light from the correct area within the frame regardless of which lens is on the camera, and controls the flash duration correctly regardless of the f/stop, bellows extension, or subject density. To date, it is the most carefree system of electronic flash. Some top-of-the-line, state of the art flash units work with the camera's autofocus system to give precisely the right fill-in flash to a backlighted daylight exposure. (See also Chapter 10—Basics of Macrophotography— Flash With Close-ups)

Nothing in the world is foolproof; therefore, most automatic electronic flash units have a manual operation option. When the subject takes up only a small portion of the frame, or is off center, the automatic system may read part of the background or foreground and render an incorrect reading of the subject. When this type of situation occurs it is best to make the necessary calculations and adjustments, and operate the flash manually at full strength. Most of the older manually operated flash units have built-in calculating wheels. The calculating wheel assumes a given guide number that should be tested and adjusted accordingly. If you don't know the guide number of your flash unit and it doesn't have a wheel, you can establish a guide number by the method described in the following section.

Establishing the Flash Guide Number
The guide for a flash unit is the product of the f/stop number multiplied by the subject-to-flash distance for a given film speed. This number is your key to a proper exposure when operating a nonautomatic flash unit, or an automatic unit in the manual mode. To establish or test the guide number of your flash unit, place a subject of average density 10 feet from the flash unit (not necessarily from the camera, unless it is mounted on the camera), and expose one frame by flash at each f/stop and half f/stop. The resulting pictures will tell you which f/stop number to multiply by the 10-foot distance. The product will be your flash unit's permanent guide number for that particular film speed. Guide numbers for other film speeds may be calculated

from this first guide number (e.g., if f/4 gave you the correct exposure, and your guide number is 40 using ISO 100 film, then the guide number would be 80 when using ISO 200 film).

Fill-in Flash

Backlighting or sidelighting from the sun adds a dramatic effect to your subject. But very often, if you expose for the shadow side of the subject, the highlights from the backlighting are harshly overexposed. On the other hand, if you tone down the highlights by less exposure, the subject becomes too dark. The solution to this problem is to use fill-in flash. Fill-in flash should not be used to fully illuminate the subject as you would normally when using straight, frontal lighting flash. It is only meant to compensate for what your eye can see but the film cannot properly register. So when you use fill-in flash, you should set the power on the flash unit to one-half or two-thirds that of a normal flash exposure. The resulting image should appear as a subject backlighted or sidelighted with the shadow side still dark but light enough to see all of the detail. The perfect exposure depends on the density of the subject and how well you balance the flash with the ambient light.

Fill-in flash can be accomplished either manually or by relying on the metering system's dedicated flash. When using the dedicated flash system, read the owner's manual for your specific flash unit for the proper settings. However, to be

absolutely sure of your exposure results, use the formula stated in the accompanying Fototip.

Homemade Accessories

Any commercial photographer or photojournalist will tell you that photography is 10 percent taking pictures and 90 percent moving furniture. The life story of a nature photographer is something similar. Instead of moving furniture, the nature photographer spends numerous hours building special equipment such as blinds, towers, tree houses, tunnels, trenches, booms, backgrounds, cages, and rope harnesses, just to mention a few items. Many of these accessories must be tailored to the specific situation and improvised with whatever materials are available near the site; and a nature photographer's ingenuity is sometimes tested to its maximum.

Shutter Release Systems

Some of the self-built items are quite basic to nature photography and are mentioned here. Remote control shutter release systems are available, but they are expensive and in some cases

such as the radio control or infrared shutter release systems, still have to be attended to from a distance. Just as efficient and very inexpensive (assuming you have an electric shutter release system on your camera) is a homemade extension cord for a standard wire cable release. A common lamp cord wire of any length is spliced into the standard shutter release cable, and a doorbell button is placed on the other end of the lamp cord. The shutter is released at the closing of an electrical circuit by pressing the doorbell switch while watching the subject through binoculars. The same system may be used with a pressure mat. Here the electrical contact is made when the animal steps on a hidden pressure mat with the doorbell switch under it. With a motor drive on the camera, it will release the shutter each time the animal steps on the mat.

This and other concoctions (such as the mousetrap release mechanism, a piece of nylon fishing line stretched across a known animal path that trips an electrical contact so that the animal takes its own picture) are good for the biologist or for someone who needs a picture of a species that cannot be approached any other way. This is of minimal use for creative nature photography because you are not in full control of the resulting image.

The Photoelectric Release Mechanism

This is the ideal automatic release mechanism, and the only practical way to photograph birds in flight. You need not be an electronics technician to operate one, and a local electronics shop might set one up for you, or show you how to set up the circuits yourself. Or you can purchase a DaleBeam™ (a photoelectric system tailored to photography). A beam of light is aimed across the prospective path of a bird or animal and into a photoelectric cell (electric eye). When the beam is interrupted by the bird or animal the shutter is released. When setting up the beam, place it so that it is perpendicular to the camera and to subject line. Then hold up a leaf or twig in the beam to focus on. With a motor drive on the camera, a bird at a nest will take its own picture each time it enters or leaves the nest until the camera runs out of film (see Chapter 9—Bird Photography).

Packing and Carrying Camera Equipment

It's every photographer's dream to own a large, invisible, accessible camera bag suspended from helium balloons. Camera bags are the curse of the profession. If they are large enough to fit everything you need, then they are too heavy. The compartmentalized bags are much too bulky and don't accommodate all of the necessary equipment. They are designed for the average 35mm camera and average lenses. They almost never include room for specialized equipment for nature photography, such as reflector boards, plexiglass diffusers, or an 800mm lens. A non-compartmentalized bag will scratch your equipment, and the item you need next is always on the bottom layer. The professional suitcase styles are easily tailored to specialty use by cutting out foam compartments of any size or shape. These cases are great for protecting equipment while traveling, but not handy to work from unless you are only working from a vehicle. I like to have everything I could possibly need with me even if I am only 100 feet from the car. The cases are also bulky, expensive, and an inefficient use of space.

It may be worth considering a bag tailored to your own specific needs: a bag that you design yourself and have made by a leather craftsman. Strange as it may sound, the expense is about the same, and may even be cheaper than some of the better ready-made bags on the market.

Ideally, the serious nature photographer should have three carrying cases to travel with and to carry equipment adequately: (1) A large case such as the tailor-made case mentioned above, that contains all the equipment necessary for a long trip. (2) A small soft leather or canvas bag with a shoulder strap that can be easily folded when empty and fitted into the top of the large bag. (3) A medium-sized bag that contains the minimum necessary equipment for an impromptu nature walk to keep in a hall closet at home.

The Large Bag

Whether it's your own custom design or if you are fortunate enough to find a commercially available bag that meets your needs, this bag should contain all of the equipment and film

necessary for a long trip. It may have two levels with specialty equipment that may not be needed right away in the lower level, and standard equipment that you use most often in the upper level for immediate accessibility. This upper level compartment should also contain at least a day's supply of film and a small flash unit. The balance of your film for a trip should be stored in the lower level compartment except when going through airport security. The bag should also have two straps on the outer face for the purpose of holding a medium-sized tripod. This bag, with the tripod removed, should be no larger than the space under an airline seat. This is important so that you are able to carry on your camera equipment and avoid the agony and hassle of missing expensive baggage. Several commercially available bags that come close to this ideal are two designs by Lowe Alpine Systems, Inc.: the Lowe-Pro Fototrekker and the Lowe-Pro Fototrekker II. These bags have only one level, but they have the optional feature of being worn as a backpack. This is a blessing if it must be carried any considerable distance. A heavy bag on one shoulder can destroy one's enthusiasm for photography, not to speak of destroying the shoulder.

The Small Bag

This bag should be made of a soft, flexible material such as soft leather, vinyl, or canvas. Ideally, it should have a flat, hard or rigid bottom so that camera equipment in the bottom doesn't roll up in a ball in the center. This bag travels empty and is folded inside the top of your large camera bag. It should be large enough when opened to carry enough equipment for a day's walk, plus a "bag lunch." The equipment will vary with your type of photography but as an example, it should hold two camera bodies, a 50mm or 100mm macro lens, a tabletop tripod (or "C" clamp camera support), a small electronic flash, and two reflector boards, and at least ten to fifteen rolls of film.

The Medium-Sized or "Ready-to-Go" Bag

This is the bag that you will be using most often. It should be stocked with everything that you would be using on an all-day hike. This would most likely include everything mentioned in the above small bag, plus a few more specialty items. It should

be a much sturdier bag, however, since it will probably get much more use and abuse throughout the year. In contradiction, it should also be packed as light as possible since it will be hanging from your shoulders for many hiking hours. Outside pockets on this type of bag are a great convenience for immediate accessibility to film and small items.

Laughing Gulls *Larus atricilla* Riding at the stern of a fishing boat or ferry with a 35mm to 135mm zoom lens mounted on your camera will enable you to take advantage of a great "photo-op"

Chapter 4

Content, Lighting, and Composition

Stopper is the term used at *National Geographic* (and other magazines) to describe an exceptionally good photograph. It's a photo that stops you while you are flipping through the pages. This is the kind of quality that seems to jump right out of the magazine or book, and you stay with the picture for a while. It almost always contains exceptionally good content, lighting, and composition—the three qualities that make up the title of this chapter.

Content

Something caught your attention so profoundly that you were compelled to record it on film, and show the rest of the world what you saw. After all, that's why you are a photographer. It's the expression of your emotions in a graphic form. And the thing that grabbed you is the content (the main subject, other objects, and background) of the picture. The subject is the main event in the picture and everything else must flow around it, or be excluded from the

picture. Nothing within the frame should compete with the main subject. If it's a tree, it's the most beautiful tree you ever saw, and it's in a most beautiful setting. If it's an animal, it's the most magnificent of its species and it is standing in a great background, or possibly doing something spectacular.

Good content has a point of reference, the first thing you see when the picture appears in front of you. It should be an interesting subject. But a good subject by itself may draw the attention of some people because of the interest in the subject they bring to the picture. But a great subject in a great setting will not draw the attention of anyone else unless it is well composed with good appropriate light that brings out the form and color and creates the mood of the whole image.

Lighting

The first definition of the word photo according to Webster's *New Collegiate Dictionary* is light: radiant energy. The stopper photograph almost always contains a type of light that emits a radiant energy toward the viewer. Even a bad subject looks "not so bad" in a rich, warm light. I learned *that* from my fifteen years of advertising photography.

Light is the single most important element in your photograph. Without light you have a black space. With bad light on a good subject, you won't get the viewer's attention. With good light on a good subject, you have the elements of a winner. With these two elements conquered, you can even improve a bad composition by cropping.

Most outdoor photography is enhanced by early morning or late afternoon oblique light with its warmth and sidelighting effects. It is especially good for mood landscapes (see Chapter 5—Landscapes). The closer you are to the equator, the shorter this time of good light will be. In the northern regions of the United States, the shorter days of winter actually give us an even longer period of good light. These periods are also the times of day when wildlife is most active, and photographers should be.

Midday bright sun is fine for illustrative animal portraits. It produces well-lighted sharp images that sell. However, some

subjects such as white fur or feathers, or snow scenes can become bleached out and lose all detail in bright sun, and would be better in light overcast. Scenes from deep within a forest are much too contrasty on sunny days, and work much better with the diffused light of overcast or even the beautiful effects of a heavy fog. Water reflections are especially high in contrast when the sky is both in the picture and also part of the reflection area. This situation is a candidate for a ND .6 graduated neutral density filter. If you are caught without one, take a meter reading of the area in the water and bracket with plus exposure up to the point of the meter reading of the sky itself. There is no correct exposure along the scale, but one of them should be acceptable.

Composition

Before we get into the rules of composition, one important point should be made. Once learned and understood, these rules may be broken in many situations, as long as there is some compensating factor that corrects the balance or aesthetic value of the picture. They should be considered guidelines, not laws.

1. *Keep the composition simple.* Leave out the unessential. Include only those elements that are important to the scene. A botanical garden scene with a splash of obtrusive color, or differently shaped shrubs every few feet may become quite busy and disturbing, which is not the emotion most of us would like to present to the viewer. This rule is sometimes referred to as the KISS rule of composition, which when spelled out is:

 Keep
 It
 Simple,
 Stupid!

 Not complimentary to violators of this rule, but it gets the point across.

2. *Keep the color balance simple.* When examining the work of the masters of landscape photography, we find that the most pleasing color landscapes lean toward the monochromatic and are not busy with many different elements. A

good color photograph does not need a splash of red or yellow. Such a splash may give life to the picture, but whether it improves or destroys a picture depends on the situation. Improved or not, the picture may run the risk of taking on the old stereotyped "Kodak look of the 1950's" (no offense to a good company).

3. *Emphasize one and only one element of composition as a point of reference.* Two important elements within a frame may compete for the viewer's attention, thus causing confusion and an overall imbalance. Place the most interesting element in a strategic position in the picture. This position is generally one-third up or down, and one-third in from either side. This is called *the Rule of Thirds.* Try not to place a point of reference object directly in the middle or too close to the edge. Even a scene with no particular point of reference can be more interesting if its proportions are not entirely equal. A pastoral scene with a sky on the top half of the frame, a field on the bottom half, and the horizon in the middle may have perfect symmetry, but be quite boring. You could improve the balance by elevating the tripod and pointing the camera downward slightly to include more foreground so that it will occupy two-thirds of the frame.

4. *Keep the balance of elements within the frame fairly uniform* (i.e., avoid sudden large areas of sky or foreground). A slight change of position may put an overhanging tree branch into part of the sky as an in-the-frame border, or place a large boulder or bush in an overpowering span of foreground. The picture should have a pleasing form to which the viewer's eye will be drawn first, then to other complementing elements and back to the original form (assuming the form is the point of reference).

There may be situations where the subjects themselves are all you want in the picture, and objects to either side within the frame would compete for attention. In such cases, place some foreground elements (the leaves of a tree perhaps) close to the camera with the lens aperture set wide open. When focused on

the subject, the lens' depth of field will throw the foreground elements out of focus, creating a border of softness around the subject, and cover up the unwanted objects.

After studying a composition in the viewfinder, you may find that you have all of the elements where you want them but the balance still isn't good and it just doesn't seem to "fall together." Ask yourself, "What is the lighting doing to the composition" and "Where will the shadows fall at a different time of day and will they bring the elements together?"

FOTOTIP 4

EVALUATING A PHOTOGRAPH

Anyone can look at a photograph and tell you what they like or dislike about it. Quite often, however, something just doesn't seem to make it and you can't put your finger on it. In these cases break down the elements of the picture to identify what is wrong or missing. The following are some terms to label and describe these elements:

CONTENT—POINT OF INTEREST

With everything else perfect, but without an interesting subject to get the viewer's attention, you merely have a good exercise in lighting, form, color, etc.

LIGHTING

The single most important element of photography. Be conscious of what the light is doing to your subject.

Contrast: flat or dark shadows, sharp or misty.

Warm or cool light

Direction: overhead or oblique

FORM

Shading of subject

Texture

Patterns

Static or dynamic

COMPOSITION

Rule of thirds (position of subject within frame)

Direction of subject (which way is it facing)

Backgrounds

Size of subject

POINT OF VIEW

Position of camera (low-to-ground or elevated)

Angle of view (focal length of lens)

Distance from subject (in proportion to the background and foreground)

With these points in mind, always ask yourself "How could I have improved this picture?"

Part II

Nature
with a Normal Lens

What is a normal lens? It used to be the 50mm lens that "came with the camera." It produced "normal perspective" viewing. Then zoom lenses became very popular. So, for now, let's forget about the normal perspective and consider a range of 35mm–100mm as being a normal lens—or any lens that you would "normally" have on your camera. That's a stretch I know, but when you start out in nature photography, chances are you have one camera and one lens, and that's what you use. The next three chapters cover nature photography within this range. The last chapter, Chapter 7—Zoo and Captive Animals, covers this range and is a transitional stage where you will be using primarily a "normal" lens, but will have many occasions to use longer focal length lenses.

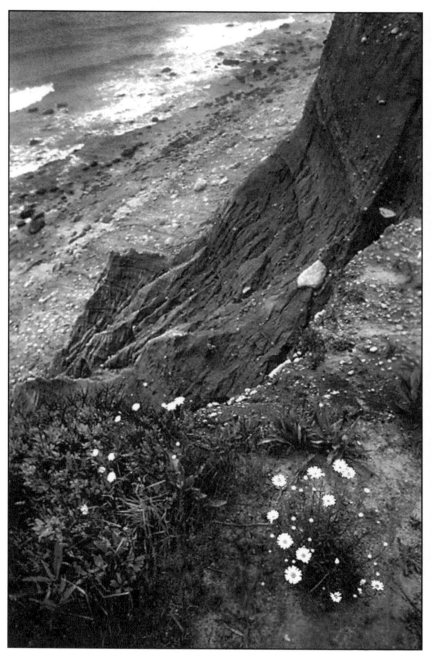

MONTAUK POINT, NEW YORK

Chapter 5

Landscapes

Landscape photography, more than other branches of photography, is a blend of artistic talent and technical skill. Seeing the landscape as a picture that communicates an emotion requires patience and a practiced mind.

Seeing Landscapes

How does one see landscapes? Have you ever taken pictures of "pretty scenes" while traveling only to be disappointed with the results? And when the prints or slides came back from the processor they didn't even come close to the same emotions that you experienced when you pressed the shutter. These pictures would never serve one of their primary functions, i.e., communicating the emotion to a viewer who has never been to that place. The solution is to learn how to see a landscape. Examine both the scene and the emotion. Is the scene beautiful in itself, or is it moderately beautiful but helped by the sweet smell of jasmine in the air, or by the mood you bring to the scene? A scene can visually fool you when stimuli to the other senses are present in the same way that a person of average good looks can suddenly take on a new and "visually" beautiful dimension by that person's verbal charm.

Isolate the Subject Area

Before you put the camera on the scene, try this little test. Make a rectangle with your hands and frame the area that you think looks good. Bring your hands/frame in closer to your eyes to include more of the scene, and farther away from you to include less. Once you have decided that the scene really is beautiful without music or fragrance, examine the scene still further to determine its visual essence. Is it the broad expanse of the color spectrum on the predawn horizon? Or is it one segment of the forest where the dark, wet tree trunks stand in contrast to the mist that engulfs the forest? Whatever the visual stimuli may be, isolate the scene in the viewfinder and examine it further. This isolation may mean zooming in or out, or changing to a lens that better fits the scene, or moving to a better location. Train yourself to become visually sensitive to what makes a good picture. Even though we commonly use the term taking a picture, think in terms of *making* a picture.

Content/Lighting

Once you have isolated the subject area in the frame reexamine it for content (hide telephone wires or other unwanted objects behind a tree if you can) and lighting. If lighting was the original emotion-provoking element, as it so often is, then you'd best make the exposure quickly before the light changes. If the lighting is less than perfect, you may do better at a different time of day. As a landscape photographer, you should examine your chosen scene with vision of how it would look at a different time of day and in different weather conditions. Fog may block out an undesirable background, or harsh shadows may disappear with a slight overcast. Backlighting may add a glow to foliage that makes your photo a prize winner. You may decide that a particular view of the mountains would be more dramatic if their tops disappeared into storm clouds (as they so often do).

The single most important element in landscape photography is lighting. The sun and the weather are not always cooperative; therefore, it may take patience and persistence to make an outstanding photograph of your selected scene. You may be

lucky on the first visit, or you may have to return countless times to attain your goal. Ansel Adams revisited the same spot at Yosemite Valley (Inspiration Point) many times over many years. His persistence resulted in the beautiful and very popular "Clearing Storm." On the other hand, he made "Moonrise Over Hernandez, NM" by quickly pulling over his jeep to the side of the road and managing to get one negative exposed before the lighting changed. Again, the secret of good landscape photography is being there when the light is right.

In landscape photography, as with all nature photography, one basic rule holds true: *Love your subject more than your camera.* When this attitude is applied to landscape photography, it means that you are going on a nature walk to examine and appreciate the sand dunes along a barrier reef, or the rock formations of a canyon wall. You are *not* going out to "shoot landscapes." Only after you have appreciated and studied a particular niche of nature's beauty are you able to record on film the visual elements that evoke the emotions.

One last suggestion, which you may discover for yourself after a few landscape studies: It is best to work alone, walking at your own pace, and remaining in one spot for as long as you feel is necessary. Even with the most cooperative company, you will find your concentration disturbed by the awareness of another person's presence and feelings. It is always nice to share a beautiful place with someone close, but plan on coming back alone for further studies.

Composing a Landscape

There are people who speak the English language fluently without knowing or ever having studied the rules of grammar. These are people who have been raised in an environment where only proper English was spoken and who have good verbal aptitude. By the same token there are people who, from childhood liked to sketch and doodle, and were born with a good sense of composition. If you are one of these people, skim this section lightly and let your instincts guide you. The rest of us will take a closer look at the rules of composition.

Lighting may influence your composition. An otherwise bland subject, when given a halo by strong backlighting, may become an all-important point of reference in your composition. A small group of wildflowers may do the same in a dark overcast scene when strategically located within the frame as a contrasting point of reference.

There is a more complete discussion of the basic rules of composition in Chapter 4—Content, Lighting, and Composition, Please become familiar with them and understand how they work. Especially note the **KISS** (keep it simple stupid) rule, which in landscape photography means leave out the unessential. Landscapes have a propensity to become busy. An artist with a sketch pad has an advantage of putting only beneficial elements in the frame. The photographer, on the other hand, has the burden of finding a way to remove unwanted elements without defacing Mother Earth. Tighter cropping or changing position can usually make them disappear.

Also important in landscape photography is the rule of thirds. One element (usually the main event or subject) within the landscape should be a point of reference located at or near one of the four intersecting points. (See Chapter 4—Content, Lighting and Composition.) The form of the point of reference should lead the viewer's eye to other points within the frame.

Camera Format

To decide which tools best suit your needs, consult the masters. During the post-Civil War period and the settling of the Western frontier, nineteenth century landscape photographers, such as William H. Jackson, Mathew Brady, and Timothy O'Sullivan, carried heavy and bulky large-format cameras into the field. The photographs are both technically and artistically great even by today's standards. Time may not be a factor in judging artistic talent, but speaking technically, today's 35mm and 6 x 6-cm fine-grained films and computerized lens formulas do not rival the sharpness and detail of these nineteenth century large-format prints. Even today's landscape photographers, although they use a more varied assortment of format sizes, rely most

heavily on the standard 4 x 5-inch view camera. Eliot Porter may have used 35mm and 6 x 6-cm format cameras for his bird photography, but he was most famous for his landscape photography, almost all of which was done with a 4 x 5-inch view camera. He felt that the sharpness and versatility of the view camera was well worth the burden of carrying such heavy equipment into the field.

On the other hand, the smaller format cameras should not be sold short. If all you have at present is a 35mm SLR, then by all means put it into landscape service. David Muench, whose landscape photography has been seen beautifully reproduced in *Arizona Highways*, uses 35mm cameras in addition to a view camera, and with excellent results. There are situations when the smaller 35mm and 6 x 6-cm cameras are the only practical solution to landscape photography such as strenuous mountain climbing or extended backpacking expeditions. However, the tried-and-true camera of most professional landscape photographers is the 4 x 5-inch view camera.

If you are presently using a 35mm SLR, you may already have become accustomed to its freedom of movement and spontaneity. Working with a view camera requires a whole new approach to your methods of making photographs. With a view camera, the emphasis is on studying the frame for its content, composition, color, lighting, and overall impact as a design. Also, because all lenses rotate images 180 degrees, and you do not have the advantage of a pentaprism as you do on an SLR, you must become accustomed to looking at the image upside down. As foreign and cumbersome as it may seem, this view has the fringe benefit of enabling you to examine the overall design and composition more critically as a pure form without much interference from the content. If you achieve excellence in the art of seeing landscapes you will eventually want to use a 4 x 5-inch "field" view camera (a compact model of view camera designed for carrying rather than strict studio use). These are strictly professional cameras. They offer little or none of the conveniences we find in the SLRs. All focusing is manual through the ground-glass camera back using a magnifying loupe, and all exposure calculations are made with a hand-held light meter and set

manually on the camera's lens and shutter. If you are focusing on a subject within 10 feet or closer, you need to calculate the bellows factor (see Chapter 10—Basics of Macrophotography) and add the necessary exposure. For a typical large-format picture there are eight things that must be done after the camera is set up and the scene is chosen and analyzed. Here they are:

1. Fine focus with a magnifying loupe, and tilt and swing the front lens board to bring near objects into focus together with distant objects using the Scheimflug Principle (see Fototip 5).
2. Take a light reading with a hand-held light meter.
3. Calculate the bellows factor, if needed.
4. Close the shutter (it had to be open to focus).
5. Set the aperture and shutter speed according to meter plus bellows factor.

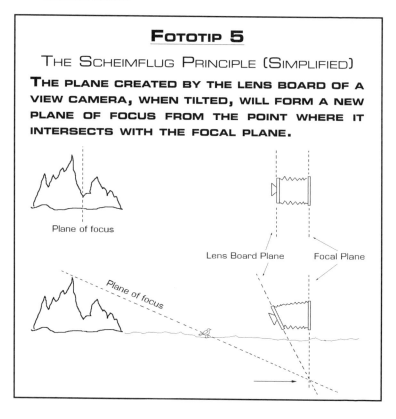

FOTOTIP 5

THE SCHEIMFLUG PRINCIPLE (SIMPLIFIED)

THE PLANE CREATED BY THE LENS BOARD OF A VIEW CAMERA, WHEN TILTED, WILL FORM A NEW PLANE OF FOCUS FROM THE POINT WHERE IT INTERSECTS WITH THE FOCAL PLANE.

Plane of focus

Lens Board Plane Focal Plane

Plane of focus

6. Insert film carrier into camera back and pull slide.
7. Squeeze cable release to make exposure.
8. Insert slide and pull out film holder.
9. Repeat steps 5 through 8 for any additional bracket exposures.

Keep in mind, all of the above must be done before a possible cloud changes the light, especially at dusk or dawn.

I don't mean to overly mystify view camera technique, but it is a bit more involved than "point and shoot" photography. Also, large-format photography is something that you should grow into as you achieve an advanced level of the art using small and medium formats. If you become a serious landscape photographer with large-format cameras, the list of tedious operations becomes second nature and you will glide through them with each exposure.

Lenses

Whichever format you may be working with, most of your landscapes will be made with a normal or close to normal focal length lens. Since a landscape photograph is primarily a representation of what you "see," and since you see things in "normal" proportions, this will be the only lens you really need. Moderate telephoto and wide-angle lenses may be desirable at times to change your angle of view from a limiting position. A super-wide-angle lens may allow you to exercise more creativity with dramatic foreground shots. Telephoto lenses, however, are of marginal value even in a creative sense, but may come in handy when you need a smaller angle of view.

One very essential item is a sturdy tripod. It is an absolute necessity when dealing with low-light situations where you need all the depth of field the lens will allow. Also, you wouldn't want to consider using a medium- or large-format camera without a rock-steady tripod under even the best of conditions. (See Chapter 3—Accessories, and Chapter 9— Bird Photography sections on camera supports for more information on this subject.)

What to Look for Throughout the Year

Once you have become addicted to landscape photography, you will undoubtedly return to your favorite spots many times throughout the year. During all four seasons you will probably explore many new places. In either case you will discover or rediscover how landscapes change not only by the season, but also by the day and hour. As you become familiar with an area you will be able to judge the best time of day and season to return. One visit with a compass should give you the information to predict where the sun will be at various times of the day and year and not waste your time by showing up at the least opportune times or seasons. Here are a few pointers that may help you make the best use of time during each season.

Spring

Beginning with spring, when everything comes to life, the bright yellow early morning side lighting adds a sparkle to the bright green leaf buds, dogwood blossoms, fields of wild-flowers, or a fresh green hillside. Very early spring, when the ground is still cold and mist rises from ponds, rivers or even wet ground, is a perfect time to capture the sparkling mist mood shot. A strategically placed salt lick may attract deer, which could make a very desirable point of reference as a backlighted silhouette in a golden misty scene. Check the legality in your area. The law frowns upon hunters using salt licks as an unfair hunting practice, and so do I. But we are shooting film—not bullets.

Midsummer

As any naturalist/photographer would tell you, midsummer is the least active and least visually inspiring time of year. Foliage has turned dark green and in some years, gypsy moths or other insects have taken their toll. There are, however, certain events that you may want to take advantage of. With the exception of certain volcanic eruptions, a midsummer thunderstorm could be nature's most dynamic visual display when beautiful patterns of lightning shoot across the sky.

To capture lightning on film it is best to work about five to fifteen miles away from the storm for safety, and with

FOTOTIP 6

TO PHOTOGRAPH LIGHTNING AT NIGHT

1. **Set aperture at f/8.** *
2. **Focus at infinity.**
3. **Set shutter speed dial at B.**
4. **Aim camera at direction of anticipated lightning.**
5. **Hold shutter open until lightning strikes.**
6. **CLOSE SHUTTER, REDIRECT CAMERA AS STORM MOVES, ADVANCE FILM AND REPEAT PROCEDURE.**

*f /8 is ideal for ISO 64 to 100 if the storm is 5 to 7 miles away. If it is further away, use an aperture of f/5.6 or larger.

a 35mm camera for mobility and film economy. The procedure is rather simple. With camera on a sturdy tripod, and using a 35mm to 50mm lens:

If you are working long after sunset with a slow film, and there is no residual light from a town or automobile headlights, then you may hold the shutter open for as long as 4 or 5 minutes without fear of fogging the film. Keep safety in mind at all times, especially if the storm is less than five miles away. A tripod or an umbrella in an open area may attract the next bolt. When your skin feels the electricity in the air, it's a warning that lightning will strike nearby. Jump in the car fast.

During late summer or during a drought, the probability of a forest fire is high. Although it's contrary to what we enjoy in nature and would normally be categorized as photojournalism, fire is a dynamic natural phenomenon of destruction that is well worth documenting on film. It can be tragic to the forest's inhabitants and dangerous to yourself, but it is awesome even to people who aren't pyromaniacs.

Work with a 35mm camera for maximum mobility. At night take a meter reading from the fire itself and let everything

else become a silhouette. At all times, stay out of the way of the fire-fighters and the fire.

Fall

Fall foliage can dress up any landscape, which for most people makes autumn the favorite time of year for landscape photography. Fall foliage landscapes, however, can be disappointing. The rich colors we see on a sunny day sometimes get lost in the busyness of the picture, or they may be too harsh to be pleasing when photographed against a bright blue sky. A polarizing filter will darken both the sky and the leaves and purify the color by removing the glare, but this may overemphasize the richness of color. Use it with care. An overcast day with drizzling rain is probably best. The wetness makes the tree bark almost black and the leaves more rich in color. If the overcast is heavy, it could cause a color shift toward blue. An 81A filter (light coral pink) helps chase the blues away. Also, since large area scenics tend to become busy with color, try to zero in on a smaller niche with perhaps a single tree or bush in glowing color, backed by a rock face or tall tree trunks.

Winter

Winter lighting, at least north of the fortieth parallel, is probably the best lighting there is for the landscape photographer, and probably the least exploited lighting for the average amateur photographer. Though the days are shorter and colder, and therefore a discouragement for most people, there are more hours per day when the sun is at a low, oblique angle that gives long shadows and warm light. A snow-covered hillside in late afternoon will very often reflect both the deep blue sky and the orange or pink setting sun. The lifeless branches of deciduous trees reflect yellow or red against a deep purple northern sky. Winter can be a very colorful time of year. A freezing rain is no time to drive a car, but if you're a landscape photographer, it is no time to sit at home. If freezing rain occurs at night, it's your signal to be up before dawn and catch the first rays of sunlight shining through an ice-encrusted deciduous tree. The rewards will justify the early morning loss of sleep, and the ice will more than likely be melted off the trees by noon.

While you are waiting for a genuine ice storm, take a trip to the nearest waterfall when the temperature falls below freezing. Conditions are usually favorable for a continuous spray of mist over nearby trees and bushes. For the past twelve years I've led photo field trips to my favorite waterfall near New Paltz, New York for the New York City Audubon Society. Each year the ice is slightly different, but it has never been disappointing.

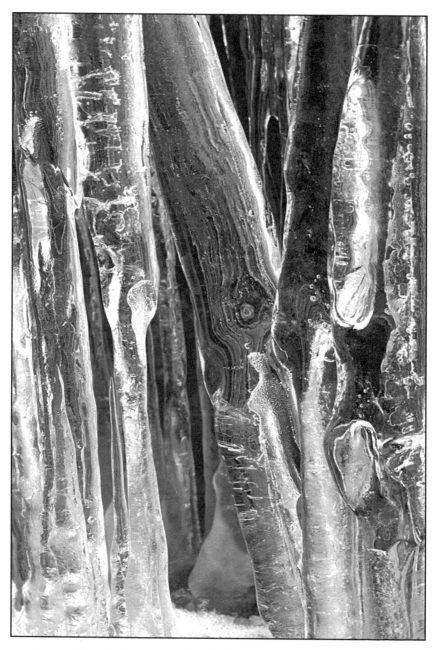

ICICLES When the temperature drops below freezing, look for a waterfall or cascading brook. You can count on something appealing.

Chapter 6

Adverse Conditions: Making Them Work for You

Some of the most pleasing mood shots have been made when the sun is not shining bright through a clear blue sky. But then who wants to take their expensive camera out into the pouring rain, snow, sea spray, or oven hot desert during a dust storm? Remember what I said back in the Part I opener—love your subject more than your camera. This chapter should help you prepare for the great and uncommon image.

Weather

Weather is a significant part of nature and should be given strong consideration in planning your photographic sessions. Second to the position of the sun, weather is the reason for changes in lighting. Some of your most dramatic nature photographs may be taken under adverse conditions, such as immediately after a violent thunderstorm (or during one), in pea-soup fog, at -30°F,

in the desert heat of 120ºF. Yes, even pouring rain has something to offer the nature photographer. All you need are the proper precautions against failure, and a positive attitude toward weather that would discourage anyone else.

Light Overcast

Beginning with the mildest of all adverse weather conditions, we should really say that light overcast or haze is not adverse at all, but an asset to the nature photographer. Almost all situations will benefit from a light overcast that does not interfere with color rendition, and gives a soft shadowed "glow" to the subject. This kind of lighting, where the sun is trying to break through the clouds, is especially beneficial to landscape and wildflower photography. No special treatment is necessary except where the haze borders on the category of thin fog, and an exposure compensation may be necessary (see Fog, later in this chapter). For landscape photography, a ultraviolet (UV) filter may help to hold the detail of distant trees or mountains, and where the overcast borders on the "gray" side, a sky filter will help to hold the warm tones.

Heavy Overcast

While light overcast may be considered the best lighting condition, heavy overcast is generally considered to be the worst. However, there are exceptions to every rule and there may be situations that would benefit from the flattening effect of heavy overcast. This condition usually requires about three f/stops of additional exposure to that of direct sunlight. Of course use your meter in these situations, but on very dark days or during late afternoon when lighting becomes very dim, most medium-quality meters tend to become slightly inaccurate. Therefore, bracket at least one additional f/stop of exposure. Also, heavy overcast tends to give the picture a blue cast. This can be corrected to some degree with an 81A filter (add an additional $\frac{1}{2}$ f/stop of exposure for filter compensation if you are not using a TTL metering system).

Heavy overcast may be a detriment to good nature photography in many situations. However, if you plan to use

electronic flash, it can actually be an asset. If you are photographing insects close up, or especially birds at the nest with flash, the quick movements of your subject will not be recorded as ghost images on the film. The flash will take the picture and stop the action without the bright sunlight recording the rest of the motion.

Rain

Artistic expression can run wild with reflections from a puddle on a rainy day. Fall foliage is at its most colorful when it is wet. A simple glossy wet rock or a droplet of rain about to fall from a wildflower can say everything a poet could say in a thousand words.

To immortally emblaze images of this poetry on celluloid you must be a bit pragmatic and use an 81A filter to restore the warm tones that a rainy day takes away from us, and allow at least three to four f/stops of additional exposure (plus filter compensation). Carry an umbrella, not just for the photographer, but more important, to keep the rain off the lens surface and camera. If you are photographing the effects of falling rain, or just happen to be in torrential rains, then it would be wise to wrap the camera in plastic bags and allow only the front of the lens to protrude. If you happen to have an underwater housing or a Nikonos camera, use it in heavy rain. A lens shade is a must, extended with thin cardboard to keep raindrops off the lens or filter. Raindrops can be seen blurring the image as they hit the lens while you are looking through the viewfinder of an SLR camera. Therefore, in a blowing rain, wipe off the lens or filter with a soft cotton cloth continuously as you are viewing, and once more immediately before making the exposure.

If you've been brave enough to take an expensive camera out into heavy rains, and you've managed to obtain some worthwhile photographs, you may feel adequately rewarded. However, your fringe benefit, if you are lucky, may be the opportunity to photograph the dramatic cloud formations of a dissipating storm. Your proverbial pot-of-gold may be a photograph of a rainbow backed by such clouds. Remember, you can only get those kind of pictures if you are there when it happens. By the way, rainbow pictures are best when underexposed by $\frac{1}{2}$ to 1 f/stop.

Fog

For excellent "mood shots" of animals, birds, or landscapes, look for foggy mornings. Fog isolates your subject, allowing it to be "framed" in an atmospheric mood of softness. Unwanted backgrounds are automatically eliminated. A normal morning mist or thin fog can sometimes be deceiving. Sunlight may not come through in strong rays, but is nevertheless very bright. The light is scattered and diffused so much that the subject may be receiving more light than it would if there was no fog. Correct exposure will most likely be $\frac{1}{2}$ to 1 f/stop less exposure than direct sunlight. The subject may appear dark only in comparison to the brightly illuminated fog itself. This is the time to take a meter reading up close to the subject and avoid the influence of the surrounding fog. Then, as always—bracket.

Snow

Snow reflects much additional light from the ground up to the subject so that a reading taken directly from the subject (at close distances) will probably indicate $\frac{1}{2}$ to 1 f/stop less exposure than normal. In direct sunlight, beware of the meter being affected by the snow itself. Use a spot meter if you can or take a TTL (through-the-lens) reading of an 18 percent gray card, or the palm of you hand.

Extreme Cold

While temperature doesn't affect exposure calculations, it can play havoc with film and equipment. At extreme cold subzero temperatures, batteries last only a small fraction of their normal life. Static electricity causes blue lightning on the film if it is advanced at normal speed (don't use a motor drive). Film tends to crack or break altogether if it is advanced too quickly. Condensation gets into everything, causing immediate functional problems and long-range oxidation of equipment. To avoid static electricity and possible film cracking, advance film manually and very slowly and steadily. Also, consider using a camera body that has a take-up spool that winds the film in the same direction that it was in the cassette. The extinct Miranda had this feature, as did some of the old Voitlander models, and a few others. Most of the latest auto-take-up spools also wind the film

in the same direction. A take-up spool that winds film in the opposite direction (as most older 35mm SLRs of the 1960's through 1980's were designed to do) increases the chance of cracking the film. Also, Ilford black and white films, as good as they are photographically, seem to crack more readily at low temperatures than other films.

As a preventive measure, keep the camera under your jacket so that it receives a little body heat. If it's too close to your body (i.e., no sweater or other garment), it may receive perspiration vapor and the eyepiece will fog. This is not a problem if it is wiped off immediately when taken out of the jacket, before it has a chance to freeze on the eyepiece. Keep a soft cotton cloth or handkerchief in your pocket for this purpose. To avoid condensation from forming on equipment when it is brought inside from low temperatures, put each piece in a plastic bag and squeeze all of the air out of the bag while still outside. Then bring it in and leave it in the plastic bags for 3 hours.

Bring extra batteries with you and store them in a shirt pocket where they will be kept warm until needed. Even with fresh, warm batteries inserted, an LCD readout in the metering system will not function at extreme low temperatures. In such cases, it would be a good idea to bring along a selenium cell meter, which works well at low temperatures and uses no batteries. Before you go on a trip to cold areas, have your cameras cleaned and meters checked. Tripod legs should be cleaned with a solvent (alcohol, lighter fluid).

Sand and Dust Storms

Rain may come straight down from the sky and therefore is avoidable by using an umbrella or plastic bag, but dust and sand move in all directions and get into everything, including lenses, camera bodies, tripod legs, eyes, ears, nostrils, and socks. Second only to a dunking in salt water, it is the most damaging element for camera equipment, and you simply can't avoid it. You can, however, minimize it and clean it up. When not in use, wrap your camera in a white towel. (Since sand, dust, and hot sun very often go together, this will act as a dust shield, insulator, and heat reflector.) Place a sweater or another towel in the top of your camera bag, even if it makes your bag too full

to close. Dust goes right through zippers, but is held back some-what by layers of cloth. After each photo session, and as often as you have time for during the day, clean your equipment, even when you know it will be collecting more sand and dust.

Tropical Heat and Light

It is amazing how much heat the human body can tolerate. Desert temperatures become unbearable at best, and frequently rise to 120°F, making a healthy person face the dangers of heat prostration. Cameras and film, on the other hand, cannot stand that much heat. In extreme hot sun, the camera itself, nicely designed in heat-absorbing black, becomes an oven in which to "cook" your film. To avoid heat as much as possible, keep the camera wrapped in a white towel (reflective and insulating) and keep your camera bag and all film out of the sun on the floor of your vehicle, preferably also draped with a white towel or cloth. Do not put camera equipment or film in the trunk of your vehicle for any long period of time because a trunk can become an oven in the hot sun. Also, carry along an extra light meter and keep it out of the sun until needed. The meter in your camera may be adversely affected by the heat after being out for only a short time. If it has an LCD readout system, it will prob-ably turn all black and unreadable when exposed to severe heat.

The tropics have a relatively short period of oblique light after sunrise and before sunset. Most of the day is filled with harsh direct overhead sun, which tends to wash out colors through reflective glare from many surfaces (e.g., flat ground, sand, leaves, water). Much of this glare can be eliminated by using a polarizing filter (see the sections on films and filters in Chapter 2—Some Basics).

The effect of going from an air-conditioned room into the tropical humid heat is similar to coming indoors from extreme cold (see above). Condensation forms on lenses and equipment. Since the temperature change is not as great, the problem is remedied in less time. As in the case of extreme cold weather, wrap the equipment in plastic bags while still inside; squeeze out the air, and leave the equipment in the bags for 20 to 30 minutes, or at least until you are ready to take a picture.

Working at Night

While it is not a function of weather, working at night can be an adverse condition. Nocturnal animals and birds depend on senses such as acute night vision and excellent audio and olfactory senses. As human photographers, we cannot depend on these senses. We can, however, get by with an electronic flash, using an auxiliary light for focusing. For night-blooming flowers and nocturnal spiders and insects, a flashlight will probably do fine. A small flashlight taped to the electronic flash unit can be used as a modeling light to predict how the light direction and shadows will affect the picture, especially when the flash unit is off the camera.

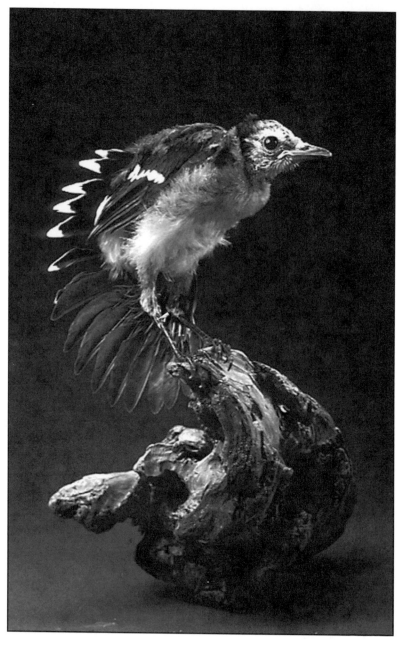

IMMATURE BLUE JAY *Cyanocitta cristata* (captive) This orphaned young bird was fed to fledgling and released.

Chapter 7

Zoo and Captive Animals

It may lack the excitement of a safari to East Africa, but a trip to a modern zoo can offer a much larger variety of animals in a simulated natural habitat. Your chances of getting good to excellent animal photographs are also much better at a zoo since shy and skittish animals become accustomed to people and will come out in the open and thus be subjects for your camera, whereas in the wild they could stay out of range for the entire trip.

Some animals seem to adapt better than others in a zoo. Seals and sea lions appear very happy and playful in captivity, whereas other animals and birds seem to lose their sparkle. Flamingos and roseate spoonbills, for instance, may lose the intensity of reddish color in their feathers. Compared to their wild counterparts, they look pale and washed out. Although this problem has been remedied in most zoos in the United States through dietary supplements, it is still a problem in many foreign countries. When photographing some of these

animals, compare their condition with photographs you've seen taken in the wild. There is no sense in wasting time and film on unhealthy looking animals unless it's for the purpose of photojournalism where it will do some good. Most zoo animals, however, are suitable subjects as long as they are properly cared for and have enough room in which to wander.

Places, such as the Bronx Zoo and the San Diego Zoo, allow large areas for each species, and thus supply good surroundings and background for photography. Some game farms have certain animals in restricted areas for safety reasons, but the large herds of deer are allowed to roam free among the people. This type of situation is ideal with normal lenses. Just be sure backgrounds don't include other people.

Try to find out beforehand when the animals are fed. This is usually the most active time for interesting shots. Later in the day you may find your favorite animals sleeping off a big meal.

A local nature center is usually a good source of animals from your own area. Many of these centers employ high school students, part time, who are interested in biology and nature, and very proud of their knowledge and rapport with animals. They will very often be most cooperative and help you photograph animals behind the scenes.

It will also be to your benefit to become friendly with the caretakers. It's always nice to return their favors with some prints or duplicate slides of them with their animals. Good photography is always appreciated since they often give slide lectures at schools and clubs. In exchange for some good duplicate slides, you may get to photograph behind the scenes and be invited back when something exciting happens, such as an animal giving birth.

Many zoos, game farms, and nature centers allow flash photography since it doesn't upset animals any more than it does people. In most cases it only produces an afterimage for a few seconds, and sometimes a startle. Some zoos, however, have skittish animals that will have violent reactions from a photoflash. If there is the least doubt in your mind, even if there are no prohibitive signs, ask permission to take flash pictures.

Animals are captive in a zoo; this means they can't escape your camera as they can in the wild. However, getting good pictures of them puts the same demands on you as would any other photographic assignment. The lighting must be right. The animal should be in a favorable location within its area, and in a good pose or activity. The composition and drama of a good photograph must be present. This may mean coming back to the same zoo and spending time there just so you will be there at the right moment. Also, zoo animals do not always wait for you to adjust your camera, so you must have your camera pre-adjusted to the prevailing light, and be just as alert as you would be on a walk through the forest.

Special Equipment

Lenses

Your choice of lenses in a zoo situation will be dictated by the subject's size and distance. This could include a range of lenses from 35mm to 300mm. For the larger animals, you would most likely find that they fit into the frame of a 100mm lens. For the smaller animals, such as mice and snakes at a nature center, you would probably find a 100mm macro lens, or a 100mm lens with extension rings, most useful. For anything as small or smaller than a mouse, or a snake's head, use the close-up methods (See Chapter 10—Basics of Macro-photography).

Shooting through a fence at a zoo is done best with a semi-telephoto or telephoto lens. The short depth of field of these lenses causes the fence wire (which should be no more than 1 inch from the lens) to be thrown so completely out of focus that it doesn't even register on the viewing screen as a significant haze. If, however, your subject is in bright sun and the fence is in the shadow area (or vice versa) the TTL method may be reading the fence as part of its exposure calculation, and an adjustment may be necessary. As always, when in doubt, bracket your exposures. Also, to keep the fence as out of focus as possible, use a large aperture for your exposure to minimize depth of field. If you are using flash through a fence, place the

flash unit up against the fence. This prevents stray light from illuminating the fence.

If, on the other hand, you are taking a picture of a large or dangerous animal with a double fence around its area (a low, waist high fence to keep you away from the higher fence that the animal may paw through), focus on the animal and then with the smallest aperture setting allowable for hand-held photography (hence slowest shutter speed), extend your arms so that the lens goes through the large fence. Aim the camera as best you can and take the picture. This assumes large animals have fences with large openings. The small aperture and resulting maximum depth of field will compensate for the slight change in distance. Good judgment is imperative, of course.

Honest but Natural

Many excellent animal photographs may be taken at the zoo, and in such natural settings that the viewer may not be aware that they were taken at the zoo. You certainly would not want to intentionally deceive the viewer into believing that these pictures were taken in the wild, but the animal portrait that you make as a work of photographic art in most cases should portray that animal as it would appear in the wild. The caption should tell the viewer were it was taken. As you take photos in a zoo, watch for signs within the habitat and on the animals themselves that might tell the viewer this is a zoo animal. Examples include cement holding rocks together, hoses along the ground, and water pans. On the animals themselves look for ID tags clipped to the ear (not often, but occasionally) or large birds in a pen with one wing tip cut to prevent flying in a straight line. This usually keeps them in the pen, but can be seen in a picture of a bird with its wings spread.

Aquarium Photography

To capture some of the enjoyment of observing and photographing life under the sea, try pointing your camera through the

glass of an aquarium. Whether you're watching small tropical fish in a home aquarium or some of the more exotic species of sea life in the Wildlife Conservation Society's Aquarium at Coney Island, Brooklyn, New York, you may find yourself mesmerized by these animals. Photographing them, however, may prove to be quite challenging. While some species remain relatively still, others seem to never stop moving long enough to get in focus. In the home aquarium there are methods to contain the fish in a small area and simplify photography. In a large public aquarium, a fish may swim out of range just as easily as it would in the ocean. If you really want its picture you simply wait until it comes back.

Taking pictures at a public aquarium is to underwater photography as zoo pictures are to safari photography. You have at your disposal many species concentrated in a small area that would otherwise take months of world traveling to see. You miss out on the adventurous entry into the natural habitat, but you are able to see and photograph species from places that you may never have the opportunity to visit.

Camera

Whatever you have on hand is the best camera to start with as long as it's an SLR (see Chapter 2—Some Basics).

Lenses

A macro lens may be needed for some of the smaller fish; and a wide-angle lens is necessary for taking pictures through the windows of the large multilevel tanks. In these tanks it is necessary to wait until the large fish comes fairly close to the glass to get good sharp pictures. Of course, this requires a wide-angle lens to get the whole fish into the frame. Also, visibility falls off almost as rapidly as it does in the ocean, even though there may not be as many particles in the water. The Wildlife Conservation Society's Aquarium is located next to the ocean, and they have an elaborate arrangement for taking in seawater. However, they find it necessary, because of seasonal changes, to use fresh water chemically converted to simulate seawater. The result is healthier water for captive fish, and slightly better visibility for the observer and you, the photographer.

A more apparent problem at aquariums is the reflection from the glass of the surrounding area behind you. Although many of the tanks are in darkened rooms, some of the larger tanks are not. In these cases it makes sense to have a large rubber lens shade mounted on the lens's filter thread. In a highly reflective situation, lightly press the lens shade against the glass. This should eliminate all reflected light.

Films

Daylight film is fine for most of the large tanks. For pictures of moving fish at the lower levels, the light loss may require a medium- or high-speed film. In tanks lighted with fluorescent lamps, use daylight film with an FL-DAY (for daylight fluorescent) or FL-W (for white fluorescent) filter. Some of the smaller tanks are lighted with incandescent lamps. For these use a high-speed indoor film such as Ektachrome 160 Tungsten, or a color negative film with an 80A filter. If you intend to use flash in a public aquarium, you should get permission first. The results of such flash pictures will normally be limited to black or dark backgrounds since the tanks are usually positioned in a wall, and prohibit top or side lighting.

A home or private aquarium, however, allows maximum flexibility for setting up good flash exposures. The problem of keeping the fish close to the front glass is easily solved by inserting a pane of thin glass (such as that used in picture frames) cut to the size of the aquarium's front panel. Insert the glass, chase the fish in front of it and move the glass close to the front panel of the tank. Allow enough space for the fish to turn around.

There are various methods of lighting an aquarium: top lighting, side lighting, front, back, etc. Front lighting must be done at a slight angle so that the flash does not reflect from the glass into the lens. When shooting through glass, approximately half of the light is lost in reflection and must be compensated for by exposure unless you are using a TTL dedicated flash system. If the tank does not have a background of plants or rocks, then a large gray or green card placed behind the tank will illuminate the black background. Use white reflector cards for highlighting other objects in the tank (plants and rocks), the same as

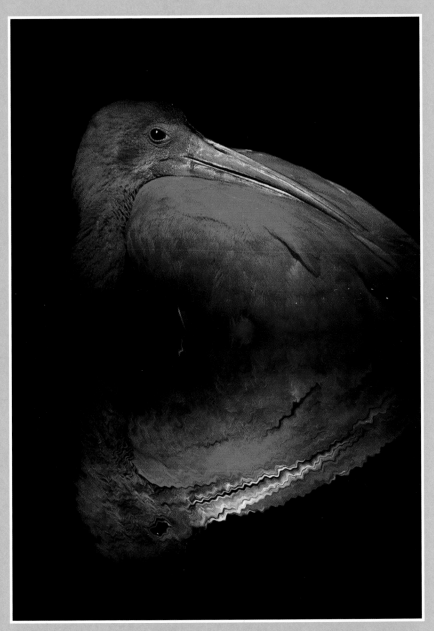

Scarlet Ibis *Guara rubra* The water reflection portion of this picture was created in Photoshop™ by flipping the original image horizontally and adding a ripple pattern over the flipped portion of the new image. (See Chapter 13.)

LONGLEAF PINE *Pinus palustris* A hazy bright sun can be a good light source. This picture follows several rules of composition including the KISS rule. (See page 47.)

KNOBBED WHELK SHELLS *Busycon carica* Cumberland Island, Georgia. The subject in this frame is placed with the rule of thirds in mind. Also, the position of the shells leads the viewer's eye into the frame. (See page 50.)

FROZEN WATERFALL Upper falls, near Lake Minnewaska, New Paltz, New York. You can depend on a waterfall on the north side of a hill to produce beautiful ice forms as soon as the temperature falls below freezing. (See Chapter 6.)

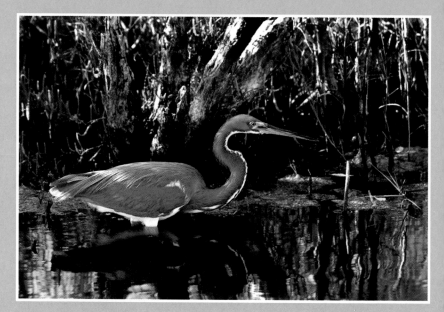

Louisiana Heron *Hydranassa tricolor* Merrit Island National Wildlife Refuge, Titusville, Florida. At times a wading bird will be so intent on fishing that it will allow you to get close enough to fill the frame. This one was shot from the car window with a 600mm lens. (See page 103.)

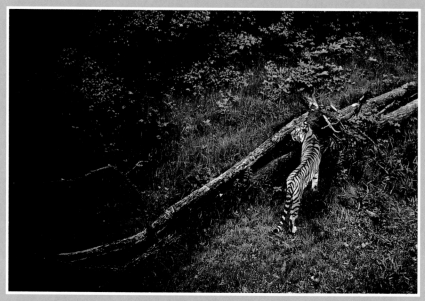

Siberian Tiger *Panthera tigris longipilis* Wildlife Conservation Society, Bronx, New York. A trip to a local zoo can help tune up your photographic skills before going on a far off photo safari. (See Chapters 7 & 8.)

FRITILLARY BUTTERFLY *Speyeria* sp. Merrit Island National Wildlife Refuge, Titusville, Florida. A 600mm lens with 50mm of extension tubes were used to capture this butterfly. This configuration allowed me to get the shot from more than 10 feet away. Any closer, the subject would have flown away. (See page 143.)

RIVER OTTER *Lutra canadensis* Chincoteague National Wildlife Refuge, Chincoteague, Virginia. These so-called wild animals were tame enough to come over to my side of the pond to see what I was doing. Fill-in flash highlighted the eyes. (See pages 38 & 86.)

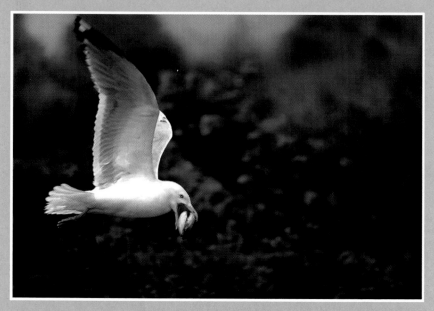

HERRING GULL *Larus argentatus* This shot was made by panning a 400mm lens mounted snugly, but mobile, on a tripod with a ball head. (See page 109.)

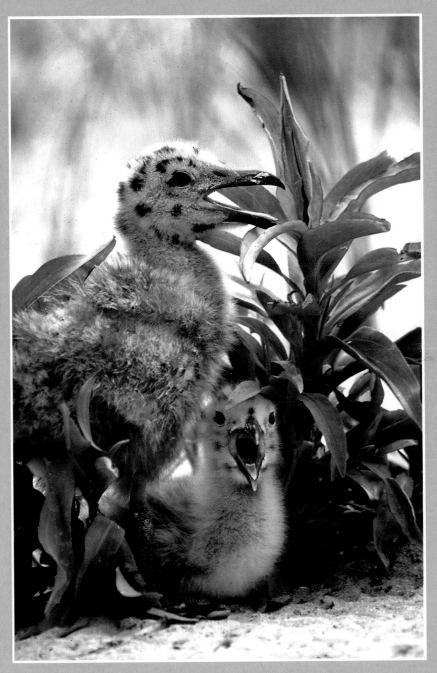

HERRING GULL CHICKS *Larus argentatus* A gull breeding colony at Captree State Park, New York. Getting down to eye level with the subject gives the viewer an intimate look at these birds. (See page 100.)

NORTHEASTERN WILD ROSE HIPS *Rosa nitida* To make the ice transparent, lightly run you fingers over the surface of the ice. This will melt and immediately refreeze the rough ice crystals into a smooth glass-like surface. (See Chapter 6.)

STREAMING WATER A slow shutter speed and a sturdy tripod will turn a fast moving waterfall into a silk design.

you would for normal photography, but the card must be placed inside the tank since the angle of refraction of water does not allow light entering the front of the tank to exit the sides. Beware of other shiny objects that might be in the room, including your camera equipment. To avoid the reflection of one of these objects appearing in the picture as it reflects from the aquarium's front plate, cut a hole in the center of a large panel of black cardboard so that the lens of your camera will fit through it, or use a rubber lens shade as mentioned earlier.

Part III

Using Long Lenses

Shall I buy a good late-model used truck, or a 600mm f/4 autofocus lens? The price is about the same. If I buy the truck, I already know how to drive it. If I buy the lens, I'll have to learn how to use it and I'll still need the truck to carry it. The point is: long lenses are expensive, bulky, heavy, and much more difficult to use than shorter focal length lenses. They are also much more limited in their use. But, for their specific applications in nature photography they are absolutely necessary. The expense alone is worthy of careful selection. The following chapters should help you decide the direction to take for your specific use.

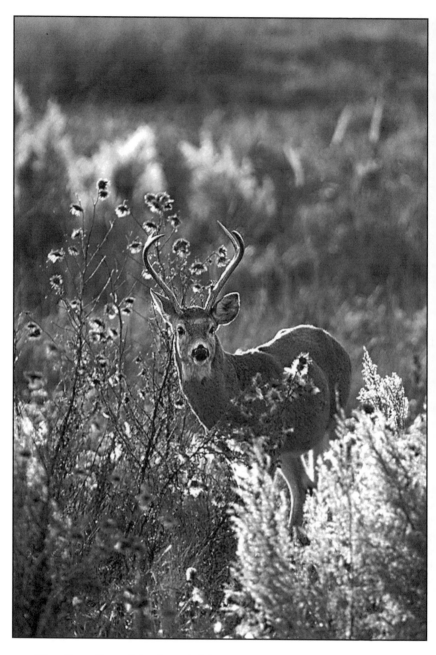

White-Tailed Deer *Odocoileus virginianus* at Chincoteague National Wildlife Refuge, Assateague Island, Virginia

Chapter 8

Wild Animals

There are coyotes wandering into downtown Los Angeles, and even Manhattan Island, and white-tailed deer appearing in The Bronx, but you will probably have to do some traveling to find large wild animals to photograph in their own habitat. For animal photography, plan to visit mountains, deserts, prairies, northern tundra, and jungles of the world.

There is great excitement in just thinking about photographing the Australian outback country, or caribou in the Yukon, or even in the United States—photographing a moose in the Alagash Waterway, Maine, a bison herd in Yellowstone Park, Wyoming, or capturing the beauty of a white-tailed buck against the morning mist in the Appalachian mountains. In any of these places that you visit for the sole purpose of photography, the wild animal portraits, photos of behavior, and action photographs will undoubtedly be the highlight of the trip.

A photographic safari can be an exciting and rewarding experience, but it is expensive. You will want to make the most of the trip. Therefore, before even planning a trip become well versed in safari-type photography and very familiar with your own equipment. You can do this on the home front at a local game farm or safari-type zoos. Even though the safari zoos in

the United States don't allow you to open your car windows, you can get the feeling of how to catch animals in their various activities through the viewfinder.

There are many national parks, wildlife refuges, and private preserves in the United States where the wild animals have become so accustomed to human visitation that they are very approachable. One of the rangers at the Okeefenokee Wildlife Refuge introduced me to Oscar, a rather large old alligator who made his rounds each day at the refuge's visitors center. I visited Deer Key National Wildlife Refuge at Pine Key, Florida, where the endangered species of key deer are not really found on the refuge itself. I was informed that they can be seen in a nearby residential area where people feed them from their back porches. These deer have become tame and very approachable, and are now even further endangered as road kills. The so-called wild ponies of Chincoteague National Wildlife Refuge on Asseteague Island, Virginia, will block the road and put their heads in the car window begging for food. Although it is against the law to feed them, people still do, and now they have a bad habit of freeloading. There are also game farms that tame and train wild animals in their normal habitat to come close enough to photograph using a normal lens. To me these are bribery situations. There you can get outstanding close-up shots of wild animals, but someone has been bribing them with food and locking them up at night. This can't be good for the species at large; and the spirit of adventure is lost in the pursuit of animal photography. The saving grace is that when published these photos allow readers to appreciate the beauty of the animals. Some of these game farms, such as 3-D and Wild Eyes (both in Montana), fall within the gray area between wild animals and zoo animals. The danger is that it supports an industry that captures and tames wild animals, an industry that even with heavy government regulations could grow out of control. They are wild animals that have been tamed, and they are in their own natural habitat but they are not free to roam. In some cases they are locked up in cages at night. I would suggest that any photos of these animals be captioned honestly.

There are places probably nearby to your own home that can be sought out and visited where wild animals are still wild. Some of my favorite places are within a day trip distance from

New York City. Jockey Hollow National Park in Morristown, New Jersey, and Edwin B. Forsythe (Brigantine) National Wildlife Refuge at Oceanville, New Jersey, are two places that I know where the deer come out of the forest through the same clearing every evening. At the Chincoteague National Wildlife Refuge there are both white-tailed deer and Sika deer (a Siberian elk) in abundance. Although people try to feed the Sika deer, they are more skittish than the ponies and don't take food as readily. They do remain visible, however, and go about their own business grazing while you stalk your pictures.

After several serious nearby expeditions to local refuges you should be equipped with at least some experience to plan a trip to some far-off place.

Know Something About the Animals

As nature photographers, we can learn much about large animals from the accumulated knowledge of many generations of hunters, expertise not only in animal habits and routines but also in tracking and attracting them to a location by sounds and odor. A hunter with a rifle has to know the game animal well enough to get the animal into his sights. The main object of the hunt ends once the gun is fired. (Hopefully the hunter missed and the animal ran away.) The photographer, on the other hand, has the much greater challenge of bringing back a trophy, that is: (1) a good specimen, (2) in a good setting with a compatible background, (3) well lighted, and (4) done without the animal attacking or running away. The greater reward for this more difficult task is looking at a Cibachrome trophy over the mantle piece knowing that the animal is still running around somewhere out there.

Most animals, when they feel threatened or cornered, will turn vicious when they don't see another way out. A bull moose may rush and gore, while an opossum will "play possum" and roll over as if dead. Surprisingly, a bear (except for the grizzly who doesn't seem to fear anything) will almost always turn tail when it sees a human, unless it feels threatened by continuous stalking or if it has cubs to protect. If you find yourself facing a snarling *Canis lupus* (wolf) or other animal large enough to do serious damage, it might be time to forget about

the great shot of a growling beast and back off. You probably wouldn't get him to sign a model release anyway.

On the serious side, I've only had encounters with black bears that stood up, saw me, and ran the other way. I've heard old woodsmen say: "Never run away from a charging bear. Just crouch face down in an unthreatening position and the bear will stop attacking." I've never had the misfortune of testing this theory, but it makes sense. I have been charged by a moose, however. I did run like crazy while the moose ran over my pack, sleeping bag, and camera equipment. No great damage except to my ego and underwear. If it were a bear, I don't know if I would have had the courage to find out whether or not the crouch theory really works. The best advice is—stay out of their way.

Animals have personalities as varied as human personalities. Quite often I've run into an individual who, although wary, was more curious about my presence than I was about that animal. During a recent trip to the Tetons, halfway up Death Canyon I tracked a mule deer who disappeared skittishly only to reappear, tracking me out of curiosity. This happened twice before she took off for good. Others of the same species would disappear without hesitation. These are rare photo opportunities, but don't go out into the field expecting them to come along. Good planning will better your chances of success.

Staying out of sight is important, but even more important is staying downwind and being quiet. Most mammals have poor eyesight, are possibly color blind, and depend more on their excellent olfactory and audio senses. The smell of a human or the snap of a twig under one's foot will give the alarm signal. As with the hunter, make the first shot count. Chances are you'll get more shots off, but very often the click of the shutter will set off the alarm. Occasionally it will be to your advantage, since the second frame may have the animal looking straight into your lens.

Many large mammals (except carnivores who must roam and hunt) are quite predictable in their daily habits. If you see a particularly good specimen that you would like to photograph, be ready to track it unnoticed and find its water source or feeding grounds. If one of its "stopping-off" points is a good set-

ting, then stake yourself out there the following day (upwind, and well in advance of its arrival).

Moose very often can be seen during the early morning hours wading into a pond or lake that is heavy with aquatic plant life. A floating blind may let you get fairly close and be safe from its charge. Once a moose is aware of your presence, it will probably leave the water and disappear into the forest.

Bears frequent campsite dumping grounds in national parks and other wilderness areas. The local ranger may point out these places if he or she trusts your animal savvy. Observe bears from a distance with binoculars at first. See which direction they come from, and the next day, set yourself up in a safe position that takes advantage of their approach with a good background—"sans" dump. If a bear finds a food supply such as a dump, a berry patch, or a beehive, it will return there as long as the food supply lasts. But for the bear's sake, and more so for yours, let it eat in peace. In the same way, a herd of deer may be followed from a distance in a well-chosen setting. Early December is the best time. Rutting (sexual excitement) occurs then, and a white-tailed buck will look his best. Behavioral studies may be photographed most successfully at this time. But be careful. This is the only time of year that a buck might be dangerous to a human. A rutting buck has "no fear."

With any new species you intend to photograph it is wise to do some library research on its habits. Tracking can be learned from a combination of research and practices by taking a guidebook along with you on a nature walk. A good choice would be *A Field Guide to Animal Tracks* by Claus J. Murie, and/or *A Field Guide to the Animals* by William Burt and Richard P. Grossenheider (both of the Peterson Field Guide series, Houghton Mifflin Company, Boston, Massachusetts). Tracking hunters know the various animal tracks and scatos (droppings), and know the habitat well, recognizing any small sign of an animal's recent presence. They learn to see anything that looks like it's out of order, such as morning dew on the leaves of bushes brushed into smooth wetness by a large animal passing by, or a small disturbance of ground leaves kicked up by a running animal, or signs of antlers being rubbed on the bark of trees.

Let us suppose that while tracking an animal, you find the perfect setting for a portrait of that animal, and it doesn't appear to be part of the animal's daily rounds, but is within its territory. If it's a moose, elk, or deer, there is a chance that you can call it in with a calling device such as a moose call or an elk bugle. The idea here is to make the sound of the male mating call. This will, in theory, immediately bring the attention of the male moose, elk, or deer who claims that particular territory. It may take a bit of practice to convince the animal that you are claiming his territory. Also working against you is the fact that during the rutting season (when looking their best), these animals depend more on smell than sound. However, the calls work well enough to give them a try. Calling devices may be purchased from Johnny Stewart Wildlife Calls, P.O. Box 7594, Waco, Texas 76714-7594, and come with complete instructions; or they may be made fairly simply by following the instructions in Leonard Lee Rue III's book *Sportsman's Guide to Game Animals,* Harper & Row, New York, 1968. (Long out of print, but this information is in several of the twenty-five books that Rue has written since then.) For an up-to-date listing of his work, write to Leonard Rue Enterprises, 138 Millbrook Road, Blairstown, New Jersey 07825-9543.

Along with the calling, you should make an all-out-effort to appeal to the animal's sense of smell. That is, first and foremost, wash out and cover up your own human smell as best you can. This means a morning shower, and clean and "seasoned" clothes. Some hunters season their clothes by a good washing, followed by a long outdoor airing, then storing them in a box of leaves, hay, cedar sawdust, or sawdust of some other aromatic wood. Second, add the sexual scent of the animal. These scents are available commercially but there are mixed reports as to their effectiveness. Some old deer hunters swear by the use of anise oil (the "licorice" smelling extract of the anise plant used in making the liqueur anisette, which they claim is far superior to the commercial lures). These days many deer hunters get themselves on the mailing list of The Buck Stop Lures Company, Inc., 3600 Grow Road NW, P.O. Box 636, Stanton, Michigan 48888-0636. This

company sells an assortment of scents at reasonable prices that will attract several species of animals during different seasons.

Predators such as many species of canine and feline as well as the large ursine (grizzly/brown/kodiak bears) may be attracted to the sound of the distress calls and death cries of smaller animals such as rabbits or birds. (Note: Please leave the bears alone; the hide you save may be your own.) Most predators will respond in speculation of stealing the prey from the animal who made the kill. Since predators must hunt for their food, and therefore must roam over a much larger area, the distress calls are effective only when the predator is in the area, or hungry enough to investigate a non-authentic call. Still, it is worth a try.

Animals can also be attracted to bait. To be effective, however, you must know the animal's territory and try to anticipate its schedule (a difficulty with predators). It also must be placed where it will, first, bring the animal into a good background, and second, offer the animal an escape route should it have to flee. If the area is susceptible to ambushing, the animal will probably not take the bait. Third, it must be upwind and visible to the animal. The bait, of course, should be something in the animal's diet. You won't attract rabbits with meat or wolves with grain. Some animals have special attraction to certain foods. Bobcats and other felines are attracted to fish and oil of catnip.

Locating animals in unfamiliar territory can be helped greatly by a local guide. The guide may be part of the arrangement if you are on a photo-tour, so choose a tour with a good reputation. Talk to someone who has come back with great pictures, and ask for recommendations and names of guides or tours in that locality. Also, local photographers are usually willing to share favorite places. It's a little bit different from exhausting a favorite secret fishing spot. Other sources can be local government equivalents of our national park staff people, and local hot-lines wherever they may be.

Besides planning your trip well with topographical maps and research, pick up a local pamphlet while you are in the area, and write down the names of each place you visit and a record of the pictures you take there. These notes will be indispensable later when writing captions.

Equipment

Camera

For versatility, speed, and quality of image, the SLR wins out again. The image of a 6 x 6-cm SLR merely by its size is superior to that of a 35mm, but for compactness in traveling, quickness of handling, and economy, the 35mm format is the choice of most wilderness photographers.

When traveling considerable distances from home, it is wise to carry two camera bodies in case the main camera should break down. It is also very convenient to carry one with a long focal length telephoto lens (most likely 600mm or larger) and the other with a shorter telephoto lens (100mm to 135mm).

Don't forget extra batteries. Most of today's cameras don't work without them.

Films

Much of the splendor in nature is color, and although most large mammals are somewhat color blind, they themselves look much better to us in color. For the most part, you will want to keep both camera bodies loaded with color film. If during a sequence of action shots you reach the end of the roll, changing lenses can be done much faster than reloading a new roll of film.

Black and white film affords animals the camouflage nature intended. If you are partial to black and white images and look for the occasion or situation that lends itself to good black and white photography (e.g., rich sidelighting on a dynamic subject with black shadow areas), then prepare for it by carrying a third camera body. The second and third camera bodies may be of a lesser expensive model of the same make, and to keep costs down again, may be bought cheaply as used equipment. The idea is to have a camera body loaded with film ready to go without having to change film for a special situation.

Lenses

Large-sized animals at the social distance, for the animal and you, demand only up to a 300mm lens. Occasionally you may need a 500mm lens. Every picture you take will not be of a large animal filling the frame; therefore, a 35mm to 135mm zoom

lens is good for the overviews that take in a bit of the surrounding area. A set of extension rings allows you to zero-in closer to a smaller (ground squirrel sized) animal than the minimum focusing distance of a 300mm or 500mm lens. If you have other lenses, bring them and be further prepared for the unexpected.

Tripods and Other Camera Supports

My philosophy of life and lenses is: Always use a tripod or other camera support, even if it is just to lean on when you're tired. Seriously, for a complete discussion on camera supports, which should apply to all nature photography, see Chapter 3—Accessories, and Chapter 9—Bird Photography. Also see the section later in this chapter titled Camera Supports on a Safari.

The Safari

When we hear the word "safari" these days we almost always think of East Africa. It is certainly the most popular place to photograph animals in their own environment, and offers more of a variety of species in a short period of time than most other places. Other places should not be forgotten, however, since they offer many species that have not been so overly photographed. Places such as the Australian Outback country, the islands of Southeast Asia, and South America offer a variety of animal life different from that which we are so used to seeing in slide shows of East Africa. Even within the African continent, places such as Southwest Africa's Etosha Pan and Etosha National Park offer animals that are reportedly healthier looking and less harassed by herds of four-wheel-drive tourist vehicles.

A good slide show from such a trip should contain more than the animal portraits. For each good picture or sequence of pictures you take of animals think in terms of developing a small picture essay of that animal's, life history. This means pictures of habits, food, territory, and interaction with other animals.

Equipment

A good travel agent and package tour will probably give you a list of what to pack. As far as photographic equipment is concerned (most likely the prime reason for the trip) you must

determine your own preparation. Before leaving, be sure all equipment has been professionally checked and serviced.

Batteries

All batteries should be replaced with fresh ones, and a supply of extra batteries should be on hand in your camera bag. Avoid the use of NiCad batteries unless you are willing to bring along a recharging unit with a 220-volt adapter. My own preference is lithium batteries, and plenty of them. Although they last a long time, hard use, extreme weather, abuse, and mistakes take their toll on even the best of batteries.

Camera, Lenses, & Film in a Tourist Vehicle

You will probably be in a four-wheel-drive tourist vehicle with other people all competing for the best space. You will be ahead of everybody if you have cameras strapped around your neck loaded with the two or three kinds of film you expect to use, and a bean bag (to be used as a camera support) in your lap or left hand. Be ready to act quickly when something happens. As far as lenses go, everything mentioned earlier in this chapter should be brought along. You will also need a middle-range zoom lens (28mm–70mm when walking or 35mm–135mm from a tourist vehicle) mounted on one of your camera bodies to show the animals in natural habitat.

Film is always a compromise. A film adequate for one situation may be totally inappropriate for the very next picture. Therefore, it is wise to have at least two or, better yet, three camera bodies with you. Two camera bodies should be loaded with color film of ISO 50, 64, or 100 (slow, but fast enough for animals in the morning sunlight with medium telephoto lenses), and the other should be loaded with a faster color film of ISO 200 (fast, but not as grainy as the ISO 400–500 color films; also works better than the slow films when using long telephoto lenses with small maximum aperture). No matter what film you select you should be familiar with the results it gives you before going on a long trip. Know what to expect from it with your own equipment and photographic technique.

How much film should you bring? Take the advice of *Life* magazine's pioneer photojournalist, the late Alfred Eisenstadt,

who recommended that you carefully plan how much film you could possibly use on a trip, and double it. As expensive as film has become, it is still much cheaper in the United States than it is in foreign countries. (See also Chapter 2—Some Basics—Films.)

On any trip, local or especially far off, your camera bag should include a small tool kit with a set of jeweler's screwdrivers, a Swiss Army™ knife or Leatherman™ tool, cotton swabs, lens tissues, and lens cleaner or lighter fluid.

Camera Supports on a Safari

If you are going on an organized photographic safari, then you will be taking most of your pictures from a tourist vehicle. In most national parks in Africa, you will not be allowed out of the vehicle. For steadiness in the vehicle, use a bean bag to rest the camera on the top of the vehicle (if you can stand up through the sunroof) or on the doorsill. Bring a tripod with you anyway, "just in case." There will be other occasions on the trip when you will need a good sturdy tripod.

Packing for a Trip

Pack all film and major camera equipment in one large camera bag. The bag should be the maximum size that will fit under an airline seat. Carry it on board and everywhere you go, and don't let it out of your sight. Attractive camera equipment cases can become "lost" as quickly as any other baggage. If your baggage should be lost, even for only a few days, you are better off with soiled clothing than without camera equipment.

Packing Film

Prepare your film for quick access at home or as soon as you reach your destination. Remove all film from its boxes and color code each film can lid with color tape, or color (Avery™ label) stick-on circles (e.g., yellow for tungsten film, blue for Ektachrome, red for Kodachrome, green for Velvia). This system cuts film reloading steps to a minimum when you are in the field and takes less space in your bags when traveling. While taking pictures, use a separate pocket or "ditty" bag for exposed film. Don't hastily drop it back in the same place with unexposed

film or you will go crazy looking for fresh film at a future critical moment.

Demand hand inspection of film by security personnel at various airport transfer points. Even though they tell you it's a slight and "harmless" x-ray exposure, when done several times it produces a buildup that will fog your film. When I have to make several flight connections on a single trip, I pack all film in a separate ditty bag within the camera bag and start out with empty cameras. At security checkpoints I pull out the film for hand inspection and let the camera bag go through the x-ray machines.

Always pack for a day's excursion at the hotel the evening before. A day in a Land Rover™ can cause lot of dust to be blown into your equipment. After each day of shooting take the time to clean and check all camera equipment, especially film advance levers (on older camera models) and lens mounts in which dust and grit collect. Tighten any small screws that may have loosened from jostling around all day in a vehicle. Lens surfaces are a continuous cleaning matter throughout the day, but should be checked and cleaned again anyway. Restock your camera bag with a fresh supply of film and pack the exposed rolls. (Do not attempt to mail film from a foreign country.) Bring it all back with you in your camera bag using the same hand inspection.

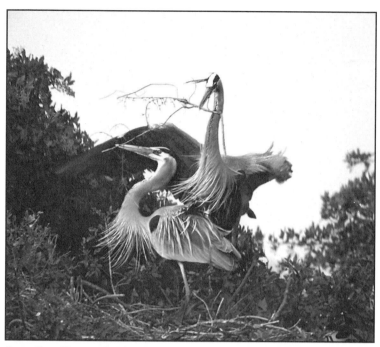

GREAT BLUE HERONS *Ardea herodias* at nest. Venice, Florida

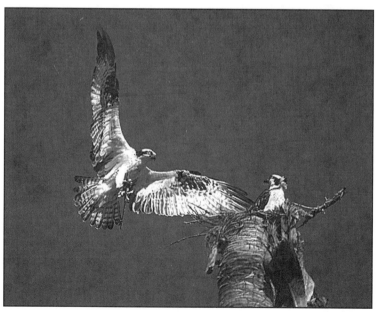

OSPREY *Pandion haliaetus* J.N. "Ding" Darling National Wildlife Refuge, Sanibel Island, Florida

Chapter 9

Bird Photography

A golden eagle swooped down from behind the barn, scared me out of my shoes, and stole a weasel skin and the board it was nailed to as I was curing it. I was eleven years old, and this was my first encounter with ornithology. I won't say it changed my life (I probably would have been a bird-watcher anyway), but it sure had a major impact. Even at age eleven I had been an avid photographer for three years, and ran for my Brownie Target 620. By now the eagle was perched on a telephone pole more than a hundred yards away and my older friend, then fourteen, had his twelve-gauge shotgun aimed at the bird. Fortunately for the eagle, my friend missed by a mile. All I really got was a picture of sky with a blurry speck flying away. But the bug had bitten. Bird photography had to be in my future.

Methods of Bird Photography

If you have a bird in your hand, just point and shoot with your other hand. If you are after the two in the bush, you need a bit more preparation. You may walk and stalk, bait and wait, or hide in a bird blind.

Walk and Stalk

The easiest and most popular method to start with is the walk and stalk method. This means carrying the camera mounted on a tripod, ready for use, until you see a bird cooperative enough to get close to with a telephoto lens and then approach slowly, frame, focus, and shoot. Don't think for a second that you can sneak up on the bird without it seeing you. Remember, birds are very visual. Some raptors have vision forty times more acute

BIRD PHOTOGRAPHER ARTHUR MORRIS crawls through the mud slowly to get close to shore birds without causing them alarm. He knows the birds' moods and habits well enough to predict their next move, and thus knows when he must stop and wait or they will fly away.

than human vision. You can, however, approach a bird unobtrusively and unthreateningly. But it takes time and patience. The slower your approach, the closer you will get to the bird. It is probably best to get as close as you can with some cover such as a tree, bush, or rock. And then get down close to the ground. This system works well in wildlife refuges when photographing wading birds as they are intently stalking their own prey. In open flats where there is no cover, such as beaches or mud flats where shore birds feed, you may have to get on your belly and walk on your knees and elbows. The shore birds know you are there, but they realize that you are in no position to overtake them and consider you safe at a much closer social distance. In some situations you can get close if there is a gap or barrier, such as a boardwalk that you are confined to or a moat that the birds know you cannot cross. One such place is the boardwalk

at the Anhinga Trail in the Everglades National Park, Florida. Here you have both a boardwalk and alligator-friendly water between you and the nesting anhingas. You still have to approach them slowly and quietly, but the social distance there is the closest I've ever encountered using the walk and stalk method.

Bait and Wait

The next method would be bait and wait. Let the birds come to you. Here you would put some suet and sunflower seeds (bait) on a rock or log in a forest or brush area where there are some passerines (perching birds). Then stand back far enough not to be a threat to your target bird. You can either use a long telephoto lens to shoot portraits while they are perched at the bait,

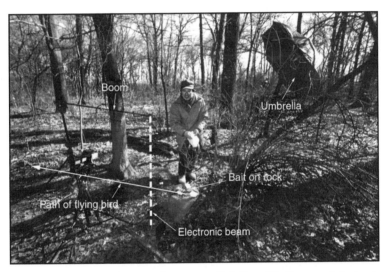

Photographer Mamoji Matsumoto has set up a DaleBeam™ with several electronic flash units around a rock that has been baited with sunflower seeds and suet. The umbrella suspended in the bush is used to shade the background and the subject as it flies through the beam.

or go a step further and use a DaleBeam™, an electric eye system commercially available for photographers.

Photoelectric Release Mechanism

The photoelectric release mechanism is the ideal automatic release mechanism, and is one of the best ways to freeze action

when photographing birds in flight. The DaleBeam™ is a commercially available unit specialized for photography. A beam of light is aimed across the prospective path of a bird and into a photoelectric cell (electric eye). When the beam is interrupted by the bird, the solenoid is activated and the shutter is released. When setting up the beam, place it so that it is perpendicular to the camera-to-subject line. To focus, hold up a leaf or twig about a foot beyond the beam, but within the bird's path. Establishing the exact distance takes some trial and error. With a motor drive on the camera, a bird at a nest or feeding station will take its own picture each time it enters or leaves the site until the camera runs out of film.

The best method is to set up a feeding station with suet, sunflower seeds, and millet on a board or a rock. Then stand back and wait. The birds will almost definitely find it and make some noise that will bring in even more birds. Observe from which direction they come to the bait, and which way they leave. They all tend to enter the area on the same side and leave on the other side (usually by being chased out by another bird). Once you see how they approach the bait, move in and arrange the equipment for the best angle and background.

Bird Blinds

No matter how good your walk and stalk or bait and wait bird pictures are, your chances of success are improved in some situations by working from a blind (in the United Kingdom it is called a hide). While this may not be true when photographing other animals that depend on the olfactory senses and can smell humans with or without a blind, birds have little or no sense of smell and depend almost entirely on sight and sound for their survival. When you are in a blind, you are out of sight and out of the bird's mind. Loud sudden noises that you make inside the blind may startle birds, sometimes enough for them to fly away. However, most noises caused by normal movement within the blind will not be recognized as threats and the birds will return to their chores after a short investigation.

Working from a blind requires time and patience, but it allows you to be more selective than with other methods of bird photography. If you know of a particularly good feeding area or

spot a picturesque nest, a blind will allow you to move in and photograph the subject while it is relaxed and unaware of your presence. To get a taste of working from a blind and test your own patience and temperament, visit a national wildlife refuge or a sanctuary that provides permanent blinds for the purpose of photography. They may not be in the best location, but they are usually located near water or feeding areas preferred by several species of birds. The use of these bird blinds sometimes requires a permit, but often is free. Registration lets the ranger know who is out there. Take advantage of this requirement by asking questions and getting advice and information about the area. Local advice is a valuable tool for the nature photographer, and it is worthwhile to cultivate friendships with park rangers and refuge managers.

Car as a Blind

Many sanctuaries and wildlife refuges permit automobiles to travel on designated roads at slow speeds. The birds in these areas, especially large wading birds, are accustomed to automobiles. As long as you remain in your car they will feel safe. They will often allow you to approach within 50 feet or less before taking flight. Some excellent bird portraits can be made this way using a car window mount. In these situations the birds are merely tolerant of your presence. They are aware of you, and although the click of your shutter may not cause them to look up, the click of your car door handle will send them flying. There are several brands of car window mounts available. An inexpensive and popular one is made by Bushnell. This model has a flat vice-like clamp that clamps onto the car window when the glass is raised about 4 or 5 inches above the sill. Attached above the clamp is a pan-head with a standard threaded screw for your lens or camera body. For heavier lenses, larger, more sturdy models are produced by Kirk Enterprises, Inc., and L.L. Rue Enterprises (Rue's Groofwinpod can go on the roof of your car or on the car window). My favorite way to use a car as a blind is to let my wife drive while I play General Patton from the sunroof of my car with head, shoulders, and elbows at car roof level and a 400mm lens with a bean bag resting on the roof as a camera support. This position is a bit high off the ground

for some situations, but it gives me quick and complete 360-degree accessibility as well as the ability to capture flying birds should one fly close by.

The Portable Blind

The ideal arrangement for bird photography is a portable blind. This is a structure usually built from stanchions and cloth to form an enclosure large enough for a tripod-mounted rig, a stool, and a photographer. It is lightweight enough to carry anywhere. With a portable blind you are free to select a site and work from the best point of view.

If you have selected a nest site, you should begin by setting up the blind at least 25 feet from its ultimate position near the nest. Let the birds get used to the blind. Go to it at least once a day. Over a period of three to five days, move it forward in stages to its final position when the birds are not around. When working at a skittish breeding colony, move during the dark predawn hours, and only to the edge of the colony, never into the colony itself. (*Tip:* If you are working in a gull or tern colony, wear a hard hat whenever you enter the area. These birds can become quite aggressive and will dive-bomb intruders to protect their nests.)

Passerine (perching birds) nests are usually in hidden shaded areas where lighting is poor. You will need to use an electronic flash. Move your light stands forward gradually when you move the blind. On the light stands, mount wooden blocks painted the same color as your flash units. Do the same with a backlight unit (slave unit) from the other direction. After each picture-taking session, when you remove the flash units, replace the wooden blocks on the light stands. Once the blind is in position, it is best for the birds if it is left there in place until the fledglings have left the nest. If there is a danger of the blind attracting ignorant and destructive people, then the lesser of two evils would be to remove the blind. Such areas should be passed up to begin with unless they can be watched constantly. If you must remove the blind during the middle of the breeding season, minimize disturbance and avoid the shock of the blind's sudden disappearance by moving it away gradually, the same way you moved it in.

Entering and leaving the blind should be done with care. If a typical species of passerine sees two people enter a blind and only one leave, they will know that there is still one person in there, and they will be wary for a considerable time. Once the second person leaves, the birds will resume normal activity. If, however, the first person leaves with a jacket or shirt outstretched on a hanger, the birds will see two figures leaving, and feel safe again. These birds know the difference between one and two, but not three. Birds of the Corvidae family (crows, ravens, jays, and magpies), however, have been known to count as high as five.

Nesting birds usually do not fly directly to the nest. They find a favorite perch, and observe the surrounding area to make sure that there are no predators following them home to locate their nest. When all is clear, they will enter the nest. As a photographer, you can capitalize on this habit by preparing an ideal inspection perch for the parent birds, within range of your camera, and within a setting controlled by you. It will give you a twofold benefit: (1) You can get good portraits of adult birds under ideal conditions, possibly carrying food to the young, and (2) you will have advanced warning that a parent bird has arrived and that feeding is about to begin. This is the time to turn on all camera systems and battery packs.

In addition to the methods described above, there are a few things to keep in mind regarding the safety of nesting birds. The breeding season is a particularly vulnerable time for them. At times, if the parent bird sees a foreign animal (you, the photographer) looking in on its clutch of eggs, it may abandon the nest. Also, you may be inadvertently showing a raccoon or other predator where the nest is located. If you come across a nest that is suitable for photography, do not linger. A quick look will tell you all you need to know. Move back, and observe the nest with binoculars for a while. When you see normal activity or brooding resume, then set up your blind according to procedures. If the nest is high in a tree, climb an adjacent tree and observe. Do not climb the same tree. If, when the blind is in its ultimate position, there are leaves or branches blocking the camera's view of the nest, use a system of long strings or strong nylon black thread that can be managed from inside the blind

to gently pull them out of the way. When you are finished with a session, gently loosen the strings from inside the blind. *Never cut branches.* Cutting may expose the nest to predators, and during certain hours of the day, to direct sunlight.

Equipment

The cost of the equipment necessary for serious bird photography is considerable. For the photographer of average-to-modest means there is a temptation to accept something less than the highest quality equipment. Since low quality equipment is still expensive, it would be foolish to spend all that money and still not have first-rate, sharp, salable images. Considering the time and energy put into learning the skills and pursuing the magic moment, it would be heartbreaking to have a publisher reject a photograph because it isn't sharp enough to enlarge to a 16 x 11 wraparound cover, and it would be frustrating to miss an important shot in a sequence because you had no motor drive and had to refocus manually after advancing the film. Professional-level equipment is very expensive, but is necessary if you have even the slightest aspiration of selling your work. In any case, using the finest equipment will yield the finest quality images. In the long run, good salable pictures always stand the chance of paying for the equipment. Consider the extra money spent as an investment. Opt for name brand camera manufacturer lenses such as Nikon's Nikkor ED-IF AF or Canon's L USM lenses. These lenses are the top of the line and very expensive. So if you find them prohibitively expensive, you might consider a third-party manufacturer such as Sigma, Tamron, Vivitar, or Tokina. If you would otherwise do without, these less expensive lenses will give you professional-level salable results, and will do fine to learn with until your camera bag earns enough to warrant an upgrade. Read about the up-to-date lens ratings in photography magazines. Look through the lens while it is mounted on your camera (or one similar) before buying it. Avoid mail order bargain lenses that must be purchased blindly. Most lenses sold today have coated internal lens elements that improve light transmission and minimize back reflection (reflection from the front of an element to the back of the one in front

of it and then back again . . .) and flare. If you are buying a used lens, some of the older ones are uncoated or of an inferior early design. Check its color and light transmission by comparing it with a lens that you know is good. Remember, if the image doesn't look perfect in the viewfinder, it certainly won't look good on film. Also, look for an easy and quick-working automatic aperture control and any noticeable aberration or flare. If possible (i.e., if buying from an individual) before you buy the lens, test it at each aperture with the film you intend to use, or at least be sure it is returnable if your test results are unsatisfactory.

Camera

The format should be either 6 x 6-cm cm or 35mm SLR. To photograph birds at the nest the 6 x 6-cm format allows the use of a fast film for better depth of field on a larger piece of film. Most bird photographers, however, select 35mm for its size, weight, ease of handling, and economy. A motor drive, although not essential for a beginner, is an important tool. To photograph birds in flight, an autofocus system is a must. At present, autofocus is only available in 35mm SLRs and it is the only practical sized system with maneuverability fast enough to record a bird in flight.

Lenses

Most bird photography is done with long telephoto lenses. But within the larger scope of bird photography, the actual focal length depends on the type of bird photography, and all focal lengths may serve a function.

For a walking and stalking expedition, you will need the longest focal length you can comfortably handle along with a very sturdy tripod. With the exception of certain breeding colonies and areas where birds have not learned to mistrust humans (e.g., Galapagos Islands, Aleutian Islands), most birds cannot be approached closely enough to fill the frame with a normal or medium telephoto lens. You will need at least a 400mm lens for the larger wading birds, gulls, or hawks. A 600mm or 800mm lens may be needed for smaller birds, or for larger birds that are farther away.

Lenses with focal lengths of 600 mm or more take a bit of getting used to. They are big, heavy, clumsy, susceptible to vibration, and magnify the effects of heat waves. They should be used with a very sturdy tripod and a fast shutter speed. But, once mastered, you can expect beautiful results that will dazzle the viewer.

When focusing long lenses on distant subjects, heat waves may give the illusion that a subject is going in and out of focus. Additionally, the heat waves may drive an autofocus mechanism crazy. When this happens, focus manually as best you can. Let go of the focusing ring when the subject appears sharp even though you know the sharp focus will be lost in a second. Then hit the shutter as soon as the subject comes back into focus by itself. Fortunately, with birds closer than 75 feet, image distortion from heat waves is not a problem. Another limitation of telephoto lenses is that they usually cannot be used when shooting through a glass window. The narrow angle of view maximizes any flaw in the window glass that would, at wider angles, go unnoticed.

Mirror lenses have fixed apertures. At 500mm they are usually f/8; at 1000mm, f/11, which at 1/500 sec demands a film speed of ISO 200 in bright sun. Slower films can be used with some success, but a great deal of skill and patience is required. (For more information on lenses, see Chapter 2—Some Basics.)

Camera Supports

The shear size and weight of long, fast telephoto lenses demands the use of a rock-solid tripod (see Chapter 3—Accessories). With lenses 600mm or longer a single tripod head is not sturdy enough for shooting at slow shutter speeds. Additionally, the slightest vibration will turn any sharply focused image fuzzy, even at moderately fast shutter speeds. Sometimes you can add steadiness by placing the strap of your camera bag over the top of the lens at a point near the center. The extra weight of the camera bag may baffle the vibrations. In a pinch, the weight of your arm over a long lens may steady it somewhat at a shutter speed of at least 1/125 sec. For ultimate steadiness there is a tripod leg brace available from Kirk Enterprises, Inc., of Angola, Indiana or call (800) 626-5074. One end of the Kirk Tripod Leg Support attaches to the rear leg of the tripod. The other end attaches to the base of the camera body, giving the camera-and-lens unit a

double brace. (This telescoping leg brace has a ball joint, so it is quite flexible.)

FOTOTIP 7

HAND-HELD SHUTTER SPEED RULE

The following rule applies to hand-held photography when using telephoto lenses: Use the focal length of the lens (in millimeters) as the denominator of the shutter speed fraction.

1/MM = SLOWEST SHUTTER SPEED

For example, if you are using a 300mm lens, your shutter speed should be 1/300 sec or faster (preferably faster). Even at these shutter speeds you should use a shoulder stock for comfort and stability.

If you are tracking birds in flight, then Fototip 7 should be of help. This rule is not very practical when dealing with the weight and bulk of a 600mm or 800mm lens, but it applies with the aid of a shoulder stock brace when using lenses of 400mm or less. Birds in flight must be photographed with a free-panning camera. For this operation there is nothing better than a 300mm or 400mm autofocus lens with a shoulder stock for camera support. With the 600mm to 800mm or larger focal length lenses, use the following alternative method.

For moving or flying birds with a heavy lens, mount the lens on a tripod and tighten the tripod-head snugly but loose enough to move smoothly. Then hold the barrel of the lens with your left hand and the camera body in your right hand with your right index finger on the shutter release button. This method allows freedom of movement with the semi-sturdiness of the tripod. The best equipment to deal with the oxymoron of mobile-steadiness is the largest Gitzo Studex Series 4 tripod you can carry with an Arca-Swiss B1G Monoball head mounted to it. With this model head you are able to adjust the tension tight enough to eliminate most vibration without locking the position. The camera/lens unit is still free enough to pan or follow a flying bird. Although there are other tripod heads that are as smooth when panning they require the tripod to be 100 percent

level or the horizon will tilt as you pan. The only drawback to the Monoball—or to any ball head—is that if you loosen it quickly without holding the lens up it will abruptly fall to one side, and risk dropping to the ground. For more information on tripods and camera supports, see Chapter 3—Accessories.

Lighting with Flash

Lighting of nesting birds, in most situations, must be done with electronic flash since nests are usually in a shaded area and reflectors or flood light would be impractical and a constant disturbance. Whether you are using one, two, or three light units, place them so that the main flash is above the camera and does not cast a shadow of a foreground leaf or branch over your subject, and so that the light goes into the nest without the front of the nest casting a shadow. A fill-in flash may be off to one side, and should be farther back or more heavily diffused than the main light. A third backlight may give a beautiful rim-light or halo effect to the downy feathers of some birds. Be careful not to over-illuminate the background. (See also Chapter 3—Accessories—Flash Units, for a full discussion of fill-in flash.)

Homemade Accessories

Building Your Own Blind

A bird blind can be made out of almost anything as long as you can enter from the rear and look out the front without the birds seeing you. During the early twentieth century it was thought that a blind had to be camouflaged and blend into its surroundings, and that anything man-made would make birds suspicious. Richard and Cherry Kearton have been credited with the first successful use of blinds for photographing birds. They used mounted cow skins and sheepskins and disguised themselves as trees. It was later discovered that a tent would do just fine, as long as it was introduced in stages.

For some situations where the nest or bait is close to the ground, a pup tent can be easily converted into a blind. Although one with a floor might be more comfortable, a cheaper model that has no floor can be secured to a hollow wooden frame at its base, thus allowing it to be moved from the inside.

This feature is valuable when your angle of view is just a little away from perfect and you have to shift position slightly (slowly and gently, of course). Also, without a floor, the tent pegs can be secured from the inside.

For situations where the nest is well off the ground, an upright enclosure is needed. While most tents are awkward in shape and difficult to move or fit into a tight position, a certain style of ice fishing tent may be easily converted into a bird blind. The least expensive and most ideal blind, however, is the one you design for a specific situation. The basic design of an upright blind is a four-sided structure with cloth walls and a roof. The size should be large enough to fit a tripod with mounted camera and lens, a stool with mounted photographer, and enough ground space inside for a camera bag and any other equipment that you may need. (You may want room for a more comfortable chair.) The blind should be just a bit taller than you are. After several hours in the blind, you will want to stretch your legs and back. The cloth should be thick enough so that when backlighted through two thicknesses it does not produce a silhouette of yourself and your gear. The cloth should also be tight enough around the structure so that a moderate breeze does not cause noisy flapping that could disturb the birds or drive the photographer crazy. Dull greens or camouflage are best. Even though birds have been known to tolerate bright colors, they have a good sense of color recognition, and muted, unobtrusive colors are the safest. Colors are also safe if they are unobtrusive to the inquisitive human eye. Upright blinds may be easily blown over by a brisk wind, even when staked at the corners of the base. It is, therefore, important to stake the corners from the top with line outstretched to the ground several feet away from the base, or to nearby trees. The wooden frames (top and bottom) can be made from 1 x 2-inch pine strips or artist's canvas stretchers. Additional zippered slots in the sides will serve as viewing ports.

If you feel that your tailoring talents are not up to building your own blind, then write to: Universal Blind Corp., P.O. Box 720054, McAllen, Texas 78504, or call them at (800) 445-7345, and ask them for a copy of their flyer and order form.

Build Your Own Feeder—Your Window as a Blind

A window with a southern exposure is an excellent place to photograph birds at a feeder. On a sunny day the sun serves as a

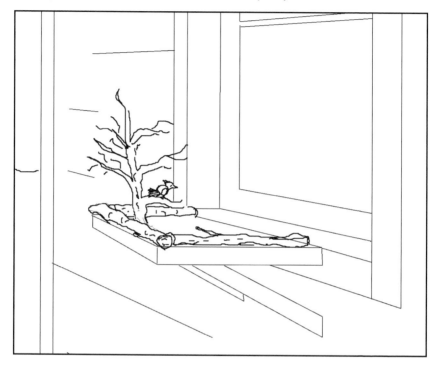

backlight and an electronic flash unit serves as the front or fill-in light. Make yourself comfortable behind a camera with a 200mm or 300mm lens and let the birds put on their show. Once the birds find out that there is free food to be had, they will show up every day at the same time, usually early morning.

A simple feeder can be built from a flat rectangular piece of outdoor plywood, 8 x 14 inches, with two angular braces that are nailed to the building under the windowsill. Around the top edges of the plywood nail four short tree branches (birch is ideal) to make a tray that holds in the seeds, gravel, and dried leaves as props. One or two branches with twigs still attached are nailed in an upright position through the bottom of the plywood (see drawing). These make excellent perches for birds to be photographed. Stock the feeder with sunflower seeds,

cracked corn, and millet. The sunflower seeds will attract grosbeaks, chickadees, goldfinches, nuthatches, sparrows, and finches, among many others. In fact, sunflower seeds are a favorite of most birds that show up at feeders during the winter months. Some species have a preference for cracked corn, such as the blue jay, house sparrow, brown-headed cowbird, red-winged blackbird, common grackle, and tufted titmouse. Birds such as the tree sparrow, song sparrow, and redpoll will eat millet.

Part IV

Macrophotography

One may travel to the ends of the earth to find subjects for beautiful photographic images. If you do just that, and you really believe that the earth is round, you will find yourself back in your own backyard. This is where you should look for those beautiful subjects—down on the ground in the grass, weeds, or fallow earth where small, wild things grow. The longer you study an area of earth—the more images there are that pop up before you. Once you are down there peaking through a macro lens, you'll see what I mean.

Sunlight shines through a decaying leaf that fell among the PURPLE HORN-TOOTH MOSS *Ceratodon purpureus*

Chapter 10

Basics of Macrophotography

Once I discovered macrophotography I spent the next two years lying on my belly looking through a 100mm short-mount lens on a bellows attachment. I was seven years old again watching ants carry cookie crumbs into a hole in the ground and finding the magnificent beauty of a wildflower that was half the size of a thumbnail. I could say lots more but I think once you start you will also become addicted.

Close-Up Equipment

The average 50mm lens will focus on subjects as near as 18 inches away from its objective element. The image at this distance will cover an area of approximately 9 x 13 inches, a good area for a tight head and shoulder portrait. To photograph a smaller image area would require moving closer to the subject; this can be done in several ways, e.g., by using diopters, lens reversal and lens stacking, extension rings, bellows attachments, or macro lenses.

Diopters

Diopters (also called close-up lenses, supplementary lenses, or portra lenses) are an extra set of lenses that screw onto the filter threads of your normal lens (or medium telephoto with matching filter thread). They actually change the optics of the normal lens to allow you to get closer to the subject. Since there is no change in the lens-to-film plane distance, no exposure correction is necessary. This is the easiest close-up system to use, although it is the least desirable in terms of results. You are actually introducing another lens element for which the normal lens was not designed and with which it may not be compatible. It will work, but with a probable slight loss of image quality. Diopters are, however, handy to have when you don't have anything else to use for a close-up picture. They take up very little room in your camera bag and, in an impromptu situation, they make the difference between a serviceable picture and no picture at all. A +5 diopter may work fairly well. A +10 diopter may show a loss of sharpness at the edges when the host lens is wide open. A +20 diopter suffers more loss of sharpness as it approaches the center. This loss of sharpness may be minimized by using a small aperture (f/11 or smaller.)

Lens Reversal

Lens reversal also does not need exposure correction because it does not change the lens-to-film plane distance. This principle works best with medium wide-angle lenses. Because these lenses are designed to work in one direction, making a large field of view fit into a 24 x 36-mm frame, the design can be used in reverse to make a small subject large on the film. Lens reversal rings are available for most cameras. In a pinch, however, a good lens reversal close-up picture may be made with a medium wide-angle lens without a reversal ring. Remove the lens from the camera and hand-hold it reversed so that the front rim of the lens is pressed against the camera's lens mount flange. By wrapping your thumb and first finger around the manually held seal, most of the stray light will be kept out. Because the focusing ring of the lens is no longer connected to the camera body, it is not operational, and you must use both hands to hold the im-

provised assembly together. Focusing is done (as with all close-up work) by moving the whole assembly back and forth until the subject is in focus. Lens reversal is probably the quickest and easiest way to make good close-up exposures; however, it is also the most limited. For each lens there is only one lens-to-subject distance and no focusing control; therefore, there is only one image size per lens.

Lens Stacking

Another makeshift way to photograph close-ups is to reverse a normal focal length lens (e.g., 50mm) onto a medium telephoto lens (e.g., 135mm). To stack lenses, all you need is a lens-to-lens stacking ring. (The Kirk Enterprise catalog has a complete list of sizes.) This is a double male ring that matches the filter threads of each of the two lenses that you are mounting face-to-face. The nice part of this operation is that it takes up almost no room in your camera bag.

Lens Extension

The conventional and safest way to make good close-ups is to put more space between the lens and the film plane. Extension rings do this by simply adding more lightproof length to the barrel of your lens. Extension rings are generally sold in sets of three different sizes that can be used individually or in combination. When used with the host lens focusing ring, a set of extension rings can handle a range of subject sizes. They are also compact enough to fit into your camera bag, taking the space of a small lens.

The Bellows Attachment

Literally and figuratively, the most flexible piece of close-up equipment is the extension bellows attachment. This piece of equipment works on the same principle as the extension tubes, putting more space between the lens and the camera body. In addition, it allows a continuous range of focal lengths without adding or taking away units. For most nature photography, the best configuration is a bellows with a 100mm short-mount lens (a lens made especially to be used on a bellows, although other lenses may be used). This arrangement allows focusing from

infinity down to 1:1 or smaller if the bellows is long enough. Most older bellows attachments may be operated with a double cable release. One cable leads to the shutter release and the other leads to the lens board that, when adjusted properly, allows the lens's automatic aperture control to operate while separated from the camera body. If your camera has an electronically controlled shutter release system (most later models do), then one cable release going to the lens board closes the aperture and a wire leading from the lens board to the camera body controls the shutter release.

The Macro Lens

At the top of the line in close-up equipment is the macro lens. This type of lens is designed to focus from infinity to life-size (1:1). With the attachment of extension rings it will focus at 2:1 or twice life-size or higher magnifications. The most popular size macro lens is the 50mm or 55mm focal length, which many nature photographers carry as their normal lens. Macro lenses are also available in longer focal lengths, such as the 100mm or 200mm, which are ideal for photographing insects or other subjects that are not easily approached.

When doing close-up work with available light, exposures are generally long and demand the use of a tripod. Also needed in this type of work is a focusing rail. If you try to focus at close distances the normal way by turning the focusing ring or stretching the bellows, you are moving the lens toward or away from the film plane as you would expect. However, as you move the lens back and forth, you are also significantly changing the distance between the lens and subject and thus continuously requiring a new lens-to-film plane distance. The subject never comes into perfect focus. Therefore, one of these distances must remain constant while the other changes to accommodate it. With small SLR cameras the easiest way to accomplish this is to fix the lens-to-film plane distance and move the whole camera-bellows-lens assembly back and forth on a focusing rail. First, establish the image size with the lens-to-film plane distance. Then, turn the focus control knob on the focusing rail to move the camera assembly back and forth until the subject is in perfect focus.

Magnification and Exposure

The high magnification of macrophotography comes with some problems involving the magnification of light along with magnification of the subject. Keep in mind that for any given lens, the f/stop number measures the ability of that lens to gather and transmit light when the lens is focused at infinity. As the subject being focused moves from infinity toward the camera, the lens is moving away from the film plane, and the gathered light that is transmitted through the lens is being spread slightly thinner onto the same 24mm by 36mm frame (usually unnoticed and compensated for by the camera's metering system) until the subject gets very close. Then the change becomes progressively noticeable. Now only an inch or so of the same light intensity as the horizon is being transmitted, magnified, and spread thin over the frame. The bright light reflected from your subject becomes extremely dim when viewed through the lens. The closer the subject, the longer the extension and the higher the magnification it creates; thus, the thinner the light reaching the film plane. When using available light, the only way to overcome this dilemma is with long exposures.

The correct aperture and shutter speed may be determined by the camera's TTL metering system. Automatic exposure systems have also added the convenience of compensation for backlighting, or dominant backgrounds, at the touch of a button. A seemingly correct exposure may be made with the photographer not having the slightest idea of what is happening in terms of exposure factors for high magnification ratios. If you want to be in control of your exposures, then you must become somewhat familiar with exposure factors for close-up work. An easy method to learn and use in the field is:

1. Take a reading with a hand-held meter (or the camera's meter using a normal lens). A hand-held incident meter is preferred.
2. With your close-up equipment, focus on a subject. Visually determine the image size ratio. Keep in mind that the vertical dimension of a 35mm viewing screen is 24mm (approximately 1 inch). If a subject 2 inches high fills the

vertical dimension, the image ratio is 1:2. If it only fills half the vertical dimension, the ratio is 1:4. If only half of the 2-inch subject fills the vertical dimension, then the image ratio is 1:1.

3. Consult the accompanying exposure factor table (Fototip 8) for the correct exposure factor and aperture compensation in f/stops. Compensation may, of course, be made with equivalent shutter speed settings. You may want to copy this table on a small card to keep in your camera bag.

FOTOTIP 8

EXPOSURE FACTOR FOR APERTURE COMPENSATION

Image Ratio	Exposure Factor	
1:8–1:4	1.5 × or ½	f-stop
1:3–1:2	2 × or 1	f-stop
2:3–3:4	3 × or 1½	f-stops
1:1	4 × or 2	f-stops

Close-Ups and Motion

The problem of vibration is ever present in macrophotography. As the magnification gets higher and the extension gets longer, the vibration becomes a bigger problem. At magnifications of 1:1 or higher, hand-held photography is ruled out unless you are using flash. This means working with a tripod or other camera support and a cable release. If you must get closer to the ground than a small tabletop tripod will allow, then rest the camera on a bean bag (which will mold itself nicely to the camera's shape).

Flash with Close-Ups

Direct flash has a well-earned reputation for being harsh. This is especially true with portraits of people, where even the slightest blemish is exaggerated by abundant illumination and perfect focus. In nature photography, we look for a certain amount of softness when we opt for available light exposures. However,

when there is no light available, we must bring in our own and soften it as best we can without losing sharpness or detail.

There are several methods of softening a harsh electronic flash. The easiest (but not the best) way is to wrap a white handkerchief or T-shirt around the flash unit to diffuse the light. This method eliminates the directness of the flash unit's parabolic reflector, but does not change the size of the light source. The shadows will still be there, but with slightly softer edges. The best way to soften shadows is to increase the diameter of the light source by directing the flash through a large diffuser or soft-box. There are several brands of small diffusers on the market that work well with close-ups.

Another method of diffusing light is to use a large white panel or card. Direct the white panel at an angle toward the subject, and aim the off-camera flash at the panel at an angle that will reflect its light on the subject without hitting the subject directly.

In all cases of light diffusion keep the following Fototip in mind (Fototip 9). The light diffuser becomes the light source; therefore, the larger the light source, the less harsh the shadows will be.

FOTOTIP 9

SOFT SHADOW RULE

There is a rule of thumb for obtaining ultimate softness of shadows when using artificial light. The diameter of the light source should equal the distance from that light source to the subject.

DIAMETER OF LIGHT = LIGHT-TO-SUBJECT DISTANCE

As the light source diameter decreases or as its distance to subject increases, the shadows become more defined or hardened.

The Dedicated Flash

There are many good flash units on the market. The dedicated flash units are especially good for the nature photographer. Most of these units work with the camera's metering system and read the light coming through the lens to control the flash duration. This means that you can use any flash softening device that fits

the occasion, and the system will adjust automatically for any variation. The system reads the light reflected from the subject after it has been transmitted through the lens, and through any length of extension. This type of system even compensates for very light or very dark subjects, and in extreme variations must be adjusted through the camera's automatic exposure compensation control dial. These dedicated flash units are usually for the top-of-the-line camera models and, therefore, are among the most expensive. The exception-to-date is the Nikon "D" system when being used with Nikon's SB-26 or -27 flash unit in 3D mode. In this case the camera's autofocusing system controls the flash duration by informing the flash unit of the camera-to-subject distance. This system is ideal when the flash unit is the same distance from the subject as the camera, and is not covered by a diffuser. In off-camera and diffuser situations, cancel the monitor pre-flash so that the system will revert to the camera's normal matrix metering system, which will then measure the light reflected from the subject and control the flash duration like any other dedicated unit. (see also Chapter 3—Accessories—Flash Units).

The Self-Compensating Method

On the more economical side, excellent results with direct flash can be obtained with a conventional flash unit and a manually operated camera body. The following list of equipment is needed for maximum flexibility:

1. A manually operated SLR camera body (may be of the older type, without any meter).
2. An extension bellows (preferably one operated by a double cable release, or any other that allows use of the lens's automatic aperture control).
3. A medium telephoto lens (105mm or 135mm). Preferably a short-mount model that allows focusing out to infinity (but a normal 50mm lens will do).
4. A small to medium-sized flash unit. If it is an automatic model, be sure it has a manual option. The unit must deliver a full power flash regardless of its distance from the subject. It also must have off-camera ability (without a hot-shoe connection).

5. A PC connector cable, which will connect the flash unit to the X synchronization PC adapter on the camera body.
6. An adjustable, flat slotted flash bracket, the type that attaches to the tripod socket on the bottom of the camera.

You probably already have many of these items, such as the camera, medium telephoto lens, and flash unit. The rest of the list, except for the bellows, is relatively inexpensive.

To work with this system, use one roll of film to test the guide number of the flash unit. It is best (but not essential) to use the type of film you plan to use for most of your work. Focus on an average density subject (a Kodak 18 percent gray card with a color chart is ideal) from a distance of 10 or 12 inches away from the lens. Point the flash unit directly at the subject and take one frame at each f/stop within a reasonable range of f/stops. If your flash unit has an assigned guide number of 55 for ISO 64 film, then the best resulting frame should be somewhere between f/16 and f/22. That f/stop, once established for your film and flash unit, is the standard f/stop for any lens-to-subject distance between 18 and 6 inches or less. The only further adjustment ever needed will be for very light or dark subjects, or for switching to a film with a different ISO rating. In the latter case, switching to a film rated at ISO 25 would mean switching to f/11.

Once you have established your f/stop for a given film, there are no flash-to-subject calculations necessary as long as the flash unit remains on the bracket secured to the bottom of the camera. As you get closer to the subject, the magnification becomes greater and the exposure factor increases. But the flash unit is also moving closer to the subject, and the decrease in light to the film, because of greater magnification, is compensated by the higher intensity of light from the flash. The system is self-adjusting.

The Modeling Light

A modeling light is a small tungsten light coming from the same point as the flash unit. It is a standard part of professional studio lighting equipment but is seldom seen on outdoor field equipment because it uses continuous electricity. The modeling light

allows you to see the subject clearly to focus and compose, and shows where the shadows will fall when the flash unit is off-camera. If you are working with close-up equipment at high magnifications, the subject appears very dark and difficult to see. A modeling light is a great help. Some "ring-lights" come equipped with built-in modeling lights, but as with the other normal flash units you must improvise. I use a small penlight that I attach to the top of my flash unit with rubber bands. It is indispensable when photographing tree frogs at night.

FotoTip 10

Suggested List of Supplementary Equipment for Macrophotography

1. Camera body, macro lens, and/or close-up equipment (bellows, etc.) with waist-level viewer or right-angle finder
2. 81A color correction filter
3. Two 5 x 7-inch (or larger) reflector boards, one side white, the other side aluminum foil
4. Eighteen percent reflective (Kodak) standard gray card
5. Flash and slave unit
6. Two or three tabletop tripods, or other small camera supports
7. "C" clamp with tripod head
8. 5 x 5-inch bean bag (a 16 oz. package of Navy [or other] beans in an orphan sock)
9. Plastic poncho (to double as ground cloth)
10. Black or dark brown background cloth (a breeze shield or changing bag may double for this need)
11. Small telescoping black umbrella (for rain, sun shade, and extra breeze shield)
12. Atomizer with water
13. Small, but sturdy scissors
14. Several feet of string
15. Clothespins (5 or 6)
16. Roll of gaffer's tape
17. Several plastic bags, including one heavy trash bag large enough to lie down on
18. Small penlight flashlight
19. Twice as much film as you think you will use

DRAGON'S-MOUTH *Arethusa bulbosa* This little wildflower is only 2 inches long, and can only be fully appreciated up close.

Chapter 11

Flowers, Plants, and Foliage

It's not what you look at, but what you see.
Thoreau

A photographer may walk through a forest in mid-April and notice groups of pretty little white/pink wildflowers growing out of the forest floor. That person may even stop at one of them to marvel at this simple but beautiful miracle, and then move on to enjoy the rest of the forest. Another photographer in the same situation, who may be more familiar with the spring beauty *Claytonia virginica*, perhaps since childhood, may also stop, but this person may search for an especially good specimen, meditate on that particular flower for some time, and discover something that he or she had never seen before in previous encounters with other spring beauties. It could be the subtle contrasting colors (i.e., the bright yellow stamen playing against the thin red lines of the petals), or simply the way the light, glowing through one or two petals and casting a shadow across the rest of the flower, lends both a softness and a glow to the flower. It should be obvious to you that, given equal technical ability, the second person would be more likely to leave the forest with the best images.

The following pages will give you much of the technical knowledge and many practical tips needed to make successful wildflower photographs, but the love for the subject, as in other branches of photography, must come from you. As you progress in your photographic skills, you will undoubtedly see improvements in your work. If you didn't come to photography with prior botanical education, then you will probably find your appreciation for wildflowers growing along with your photographic skills. Many people have come to appreciate wildflowers, mushrooms, mosses, etc., through photography. These are subjects of which good pictures are relatively easy to make, since they are colorful, have natural design and appeal, and, with the exception of fluttering wildflower petals, are inanimate. As you photograph a wildflower or mushroom, the camera brings you down to one of nature's smaller planes of existence, isolates and frames its beauty, and for the time spent looking into the viewfinder, captures your emotions by showing you something that you hadn't seen before even though it was always there, right next to your ankles. If this is your inspiration, then it would be wise and rewarding to join a local nature club and participate in classes, workshops, and field trips to increase your knowledge and understanding. Both you and your pictures will benefit from it.

Preparation and Composition

Once you have selected a subject to be photographed, whether it's a tree branch bearing fall foliage, a grouping of mushrooms, or a solitary pink lady slipper, just as with landscape photography, the frame should be studied for content, composition, color, and lighting. The advantage of this type of photography over landscape photography is that in most situations these elements are within your control. If you can, walk around your subject for the best point of view. Remove twigs and unwanted items. Since your working area is small, you may even simulate your own weather conditions (e.g., sunlight can be easily shaded and then reflected in as a softer light with reflector boards, early morning mist may be simulated with an atomizer spray of water, bright backlit sun can be simulated with flash or reflectors). The disadvantage of this type of photography is that you must

work with what you find when you find it. If you return in a few days, the subject may be gone, destroyed, withered, or significantly changed in appearance and lighting. In most cases, this factor also negates any specific planning of a particular image. It is possible to return to a subject after a few hours when the sun is in a better position, but on any one day's venture, unless home is nearby, you must pack everything you will need for any situation that might arise (see Fototip 10, Chapter 10— Basics of Macrophotography). Obstacles to good photographs arise unexpectedly, and you should be prepared for them. Isolate your subject, i.e., leave out or take out anything that interferes or competes with it (see the KISS rule, Chapter 4—Content, Lighting, and Composition). You may have to remove dead leaves from the forest floor that partially cover a bloodroot to show the beautiful red and green stem at its base, or trim back weed stems or grass with a pair of scissors, or tie back a sapling or tree branch with a piece of string. Never cut branches. If your subject specimen is ideal, but the background is impossible from any point of view, then prop up your background cloth or card with sticks, or tie it up with string, or simply drape it over your camera bag if the subject is small enough. Very often, however, a slight shift in position will get rid of an undesired object in the background. Another method is to use the lens's widest aperture to throw everything but the subject itself out of focus. Depth of field is extremely shallow at close ranges, so much so that parts of the subject itself may be out of focus while a selected part of it is in perfect focus. This technique very often produces beautiful compositions of soft fields with an accent of sharpness on one point of reference.

Quite often, breezes so soft that you hardly feel them appear vividly in the close-up viewfinder as a hurricane force gale. Tall plants with light petals, such as Jacob's ladder, or hanging flowers, such as touch-me-nots, never stop moving. If staking them or tying them off with string doesn't work, then a breeze shield may block the source of frustration. Simply prop up your background cloth, or a sweater or jacket, at an angle around the subject to protect it from the breeze. Taller plants, of course, require a larger piece of cloth.

Most photography of flowers or mushrooms should be thought of as close-up photography, demanding special equipment and exposure techniques. Close-up equipment and its usage is fully described in the next chapter on insect photography, and lighting and exposure techniques are discussed in the following section of this chapter. (see Fototip 10, Chapter 10—Basics of Macrophotography for a comprehensive list of equipment that you should have on hand for any situation.)

There may be other items that common sense will tell you to add to this list, depending on where you plan to go. For example, if you are planning to visit a marsh or swamp, you will want to bring a pair of chest-high waders, at least 25 feet of rope (to pull yourself out of the mud), and insect repellent.

Lighting and Exposure

Light is what photography is all about (photo = light, graph = drawing). You should pay special attention to what light is doing to your subject, how it is enhancing or degrading the subject's appearance. Discover the kind of lighting, in your own opinion, that best suits your subject. There are set formulas for solving lighting problems, some of which are described below. But it is up to you, the photographer, to use them or divert from them creatively to communicate successfully to the viewer the beauty or feeling you have for the subject.

Many photographers prefer the softness of color and subtle tones of indirect available light to the brightness of direct sunlight or flash. When nature's own reflections of light are not apparent, there are several methods of helping nature along. When the subject is sitting in bright sunlight casting harsh shadows across itself, simply shade it with a black or white umbrella, a large cloth, a poncho, or whatever you have available. Then, with one or two reflector boards, reflect the light back onto the subject. You may be pleasantly surprised by the soft glow that the subject assumes. A reflector may be made by stapling a piece of 8 x 10-inch white illustration board to a $\frac{5}{16}$-inch-diameter pointed dowel made with a pencil sharpener. For a brighter reflection, wrap the illustration board with aluminum foil. When

your subject is deep in the forest, or hopelessly shaded from the sun, a small hand mirror strategically placed with gaffer's tape on an illuminated tree branch will add the desired light to the subject. This is best done with sidelighting, since you don't want a rectangle of light in the background. Also, the farther away you place the mirror, the more leverage there is to the sun's movement, and you either have to work fast or anticipate the path of reflection.

There are situations where the flat lighting of an overcast day renders a very desirable picture in the viewfinder. On heavy overcast days, however, film does not respond to colors in the same compensating way as the human eye. It sees and registers a blue dominance. To bring back some of the warm tones, use an 81A filter (salmon or coral pink in color).

When photographing very small subjects, such as small fungi, mosses, lichens, with the high magnification of one or two fully extended bellows, the image on the viewing screen (especially on a dark day, toward evening, or on the dark side of a mountain) becomes very dim and difficult to focus. In such a situation, use electronic flash to illuminate the exposure (see Chapter 10—Basics of Macrophotography—Flash with Close-ups).

Beware of richly colored, brightly lit subjects framed against an equally dramatic dark shadow background area. Unless the subject itself is occupying at least two-thirds of the image area and is centered in the frame, the metering system of most SLRs will use the dark shadow background area as well as the lighted subject to calculate the exposure. The resulting picture will be an average of the two extremes, i.e., an overexposed subject and a slightly underexposed shadow detail. The method, of course, is to meter the subject and let the background go dark. If the subject is too small to fill the frame when the camera is brought closer for a meter reading, then place an 18 percent gray card, or the palm of your hand in the light that is illuminating the subject, and let the metering system read its reflection. If you are using a completely automatic exposure camera, then note the shutter speed, re-frame the image, and turn the camera's compensation dial or ISO film speed dial until that shutter speed

appears on the shutter speed indicator (consult your camera's instruction manual).

If, on the other hand, you are dealing with a subject in a shadow area with a brightly lit background, the reverse of the procedure would be appropriate and, at times, desirable. Place the scale or your hand in the shadow area, take a reading, and set the camera accordingly. However, in most cases, this will not produce an outstanding photograph, and one of the lighting techniques mentioned earlier should be used (reflector board, flash, etc.). Your most reliable exposure technique in either situation is to take a meter reading of incident light, adjust the reading by the necessary exposure factor for close-up work (see Chapter 10—Basics of Macrophotography, Fototip 8), further adjust for any filters you may be using, and set the camera accordingly. It is far more complicated, but since you are dealing with an inanimate subject, it is worthwhile to become familiar with the procedure.

A Photographic Approach to Wildflowers

A photographer who goes to a natural environment to photograph "whatever is out there" will probably wind up with an accumulation of "pretty flower" pictures that are of little use or pleasure to anyone. On the other hand, a photographer who has done his or her homework will know what to look for in any given natural environment and season, will know something about the particular species found, and will know what is unique about the plant.

Each plant species has its own natural history. It would certainly be embarrassing to have an editor or a member of your audience perform one-upmanship on your knowledge of a mushroom or wildflower that you are presenting in a picture, especially if you left out an important feature. For example, a photo of a pitcher plant flower may look beautiful by itself, but a photo of the whole plant with perhaps a maggot fly or two (flesh flies or blowflies) would illustrate how this carnivorous plant attracts maggot flies by emitting an aroma of rotting flesh that the fly needs for egg laying, and then lures the thirsty fly into its water-

filled lower part where the fly is trapped by the downward facing hairlike structures. The fly finds itself in a one-way passage where it is drowned and devoured by the plant. Less morbid but as interesting is the lily with its double row of spots that lead a honeybee deep into the flower as if the dots were running lights on a landing strip. Take the picture that shows this. The

FOTOTIP 11

THE PICTURE STORY

To tell the complete visual story of any wildflower, plant, or mushroom, you should take a series of views.

A suggested series for a botanical picture story would be as follows:

1. An overall shot of the environment showing the subject's place in it.
2. The immediate area showing the whole plant.
3. A close-up of the flower.
4. A creative or aesthetic photo rendition using any of the lighting techniques mentioned in this section, or your own methods.

Very often, the last two pictures on this suggested list mean getting both the camera and the photographer down close to the ground to look up into a trout lily, mertensia, or mayapple. For these shots, use the bean bag to rest and position the camera.

bee gets his nectar, the plant gets pollinated, you get an intelligent photo credit, and everybody is happy.

Even if your goal in photographing wildflowers is purely an aesthetic and artistic interpretation of a beautiful subject, you should become somewhat familiar with botany. If for no other reason, the study will show you the variety of potential subjects in your area. A library or bookstore will help you find reference material. A botanical society or your local chapter of the Sierra Club or Audubon Society will assist you finding courses and field trips. Also, people in these organizations generally know locations where the best specimens are to be found, and are almost always willing to share their knowledge with sincerely interested people. From these sources, gather information such as:

1. A calendar of wildflower blooming times and other botanical events for your area.
2. A list of environments or habitats that you plan to visit (e.g., swamp, desert, forest, meadow, pond, littoral zone, mountain, sand dune, bog) and the species you are likely to find at a given time.
3. Life histories of interesting species that demand special attention.

Fill your calendar with those species that you want to photograph. If you live in the eastern or central United States or southern Canada, a likely species to photograph is the trout lily, which you would put on your calendar anywhere from March to May, depending on your local area. This species should also appear on your habitat list under the heading "Forest." Keeping lists will not only help you to learn the species, but will simplify matters in following years. For example, if you were to visit a bog in April, your list from previous years will tell you some of the more obvious things to look for, such as pitcher plants, Jack-in-the-pulpit, full-grown skunk cabbage, and will remind you not to expect the beautiful yellow lady slipper you saw last year near the same bog, until May.

SWALLOWTAIL *Papilio* sp. at Cypress Gardens, Winter Haven, Florida

Chapter 12

Insects and Other Small Critters

We don't have to go very far to find insects to photograph. More often than we would like, they come to us. It has been said that entomologists fall into two categories: those who find insects to be fascinating creatures and subjects of endless interesting research, and those who hate them and do research in chemistry to find the best way to exterminate them. As nature photographers we should think of ourselves as the former, but we should carry insect repellent anyway.

The following pages will give you the basics necessary to begin photographing small creatures such as insects, arthropods, newts, frogs, and toads. A complete discussion of macrophotography basics can be found in Chapter 10—Basics of Macrophotography. This chapter is not meant to be a guide to invertebrate behavior, but merely presents examples of photography problems and their solutions.

You don't have to be a professional entomologist to get successful pictures of insects, but you should know some basics that will help you get close enough to them, and some information

to prevent making a classic faux pas. A humorous news article a few years ago told of a man who invented and marketed a machine that would attract mosquitoes away from the living area of one's property. The machine made a hum similar to that of a female mosquito and, sure enough, attracted thousands of male mosquitoes. What the man did not know was that only females need animal blood for the manufacturing of eggs. The males were quite harmless, but the females continued to attack behind the knee. So it pays to do one's homework.

Since there are more than 88,600 catalogued species of insects in the United States alone (many of which are quite colorful), a photographer will never run out of material. There is much room for original work in this field. There is also the pleasure of capturing the images of some of these jewel-like creatures on film that makes this field rewarding.

Equipment

To photograph insects means using macrophotography (the world of close-up photography). You may get involved on a simple level at first, with one or two diopter lenses (close-up lens attachments that fit your normal lens), but may later opt to plunge into the technology that will enable you to take first-rate, larger-than-life pictures of "the compound eye" or the iridescent reflections of light from the gossamer wing surface of a damselfly. Until recent years problems connected with macrophotography (such as the calculations necessary for exposure compensation and color correction filtration due to reciprocity failure of films undergoing long exposures) were enough to scare off most potential macrophotographers. However, today's TTL meters, automatic exposure systems, and improved films have made the field accessible to the point where one can begin macrophotography with a reasonable amount of success.

As mentioned in Chapter 10—Basics of Macrophotography, the longer macro lenses of 100mm or 200mm for insect photography are preferable to a shorter 55mm macro lens. These lenses provide a longer lens-to-subject distance, which is much needed in case the subject flies away when we get too close. We can take this principle a step further by using extension rings

(also mentioned in Chapter 10) with a telephoto lens. For example, if you have a 300mm lens with a minimum focusing distance of 11 feet, add 75 mm of extension and you will be able to focus within 6 feet and fill the frame with a butterfly, damselfly, or other skittish insect.

The Creatures in the Wilds

Your first attempts at photographing insects may produce some interesting portraits. These small creatures make excellent photo subjects. Most of them are easy to capture, control, and study. Once involved, you won't want to let go until you have a complete life history of a species on film. The following are some examples of possible picture stories.

- Life cycles of various arthropods (eggs, larvae, pupae, adult; or eggs, nymphs, adults)
- Arthropod structure and parts (e.g., comparisons of mandible structures of various creatures)
- Interesting habits or predatory techniques of certain species
- Camouflage abilities (e.g., many moths are the color of the tree bark upon which they rest)
- Mimicry—the comparison of an insect and its mimic, such as the monarch butterfly and its mimic the viceroy butterfly, and many harmless insects who wear orange and black—nature's danger colors—to mimic bees and wasps and to scare off would-be predators
- Artistic photographic expression of the colorful designs of moths, butterflies, damselflies, dragonflies, and others with design or color as a theme

Even straight insect portraits can be made more interesting if you look for a specimen that is doing something, for example:

- A bee with his proboscis in a flower
- An ant cleaning its antennae
- A bee filling its pollen sacs
- A wasp caring for eggs
- An ambush bug with its prey

- A spider wrapping a freshly killed victim
- A praying mantis chewing its victim
- A pair of damselflies (or other insect) mating

The list would go on indefinitely, but the point is, activity makes the portrait more interesting.

Stalking

Flying insects on a perch or flower are good subjects for artistic photographic expression. Getting close enough to them to fill the frame, however, can be quite challenging. Butterflies and some dragonflies must be stalked slowly and steadily. The coolness of early morning is the best time. The insects are a little slower to react (not much—but every little bit helps), and the lighting is oblique and softer for good available light shots. Stalking is best done as follows. (1) Establish the distance at which the insect will fill the frame, and focusing the camera on that distance. (2) Establish the angle of view and the background that you want in the picture, and approach from that direction. (3) Then move slowly and steadily to where the insect is perched, with the camera to your eye. The closer you get, the slower you should move so that the last 18 inches should take a full 60 seconds of very steady approach. Any sudden movements at this distance will startle the subject and it will fly away immediately. (4) As soon as the subject comes into focus (since your angle and background composition has been already established), press the shutter release button. Chances are you will only get one frame exposed since the camera noise will probably scare away the subject.

Photographing damselflies and dragonflies at the edge of a pond or in a swamp may be done successfully by the above method but more patience is required. Skimmers, darners (large dragonflies), and damselflies are territorial. When you select a specimen that you would like to photograph, observe it for a while to see where it perches. You may find that it has one or two favorite perches, but also frequents three or four other places. It will constantly move from perch to perch and chase away intruders as it does. Select the perch you think will make the best picture and move toward it slowly and in stages, remaining

at each stage for a minute. If you move slowly, and remain at each stage whenever the insect lands on your selected perch, it will probably not consider you a threat and will return to that perch again when you have moved still closer. When you have moved close enough to focus on the perch, remain motionless until the insect returns to it. If you are photographing with available light you may only get one frame exposed. If, however, you use flash for the first exposure the insect will become temporarily blinded on that side of the compound eye and remain on the perch long enough to expose a few more frames with available light. This method may not always work in bright sunlight where the flash makes little difference, but it is worth a try.

Spiders and their webs, especially the beautiful garden spiders *(Argiopes),* with their highly engineered orb webs can present a problem when a slight breeze occurs. The solution is to build a breeze shield (see Chapter 11—Flowers, Plants, and Foliage). If you missed the early morning dew that always enhances an orb web, an atomizer from your camera bag may provide the answer. Use the atomizer only outdoors where dew would normally occur. An orb web of an indoor spider (those found only in caves, sheds, or barns) filled with dew would appear as a faux pas. Also, use distilled water or pond water if you can. Tap water with chlorine may have a bad effect or even kill the spider.

Your Own Outdoor Studio

Bird watchers' binoculars have acquired a new focus. For more than a decade there has been a growing interest in butterfly watching. Home owners in the suburb and rural areas have been cultivating species of plants and shrubs that attract certain species of butterflies. Planting gardens for the specific purpose of attracting butterflies has been the subject of numerous articles. The articles found in local newspapers and magazines will tell you which species are found in your area. They should also tell you which species of native flowering plants are the most likely to attract those species for the purpose of nectar feeding as well as egg laying.

One would think any flower should attract any butterfly, but such is not the case. In fact a vegetable garden will probably attract more species in higher volume than a rose garden. The arrangement and position is also important. If the planting begins at the border of your property near a neighbor's planting or the edge zone (the zone between the forest and meadow), and proceeds along a continuous line of flowering plants that the butterflies can follow, then you will have a much higher volume of occupancy. Apparently, butterflies tend to avoid flying across large open spaces.

A wealth of information can be obtained from the North American Butterfly Association, Inc. (NABA). For a small fee ($2.50 as of this printing) they will send you a set of brochures entitled *Introduction to Butterfly Gardening*. There is also an excellent article on butterfly gardening entitled "The Basics of Butterfly Gardening—with a Northern Slant" by Bernard Jackson in *American Butterflies* (the journal of NABA) Spring 1996, Vol. IV, No. 1. This article is very helpful to anyone starting a garden in the northern United States or southern Canada where the number of species of both plants and butterflies are fewer and more specific in their compatibility with each other. Another source of information on butterfly gardens can be found on the internet at: http://www.best.com:80/~gardener/. This page includes hyperlinks to urban gardens and regional species.

The Creatures Indoors

Indoor Sets

Photographing arthropods in their natural habitat is relaxing, rewarding, and educational. But for the sake of recording certain facets of insect behavior and to photograph certain species in their splendor that are simply not visible in normal daylight hours, as well as for many other reasons, we must resort to laboratory or studio conditions. To the entomologist it's a laboratory, to the photographer it's a studio, to anyone else, it's a garage, shed, or basement. Any available place where you can, by some means, control the temperature will make a satisfactory studio.

In this studio/laboratory you will be able to photograph sequences such as the stages of a butterfly larva wrapping itself in a chrysalid and later emerging as a butterfly; or a spider laying its eggs and the subsequent hatch; or simply the splendor of the many species of nocturnal moths and bugs that you've caught in a homemade trap and placed in a terrarium or other improvised habitat.

Insects in Flight

Flying insects are a challenge all by themselves. It is possible to photograph a bee in flight while it hovers in front of a flower, but to stop wing motion is a specialty in itself. In 1962, Dr. Roman Vishniac, the famous photographer of the Polish ghettos, photographed a cicada killer wasp in flight by forcing it to fly through a tube so that it would trip an electric-eye controlled shutter release. The exposure was made with electronic flash firing at a speed of 1/175,000 sec (although there were rumors that in his later life he admitted mounting the insect on a hairpin). Many years later, Stephen Dalton with the help of Ronald Perkins of the Central Unit of Scientific Photography (England) perfected electronic flash systems so that a strong enough flash was used to expose insects in flight on ISO 25 color film. The results were very sharp and beautiful color photographs of insect flight. They can be seen in two of Stephen Dalton's books: *Borne on the Wind*, Ghatto & Windus, London, 1975, and *The Miracle of Flight*, Blacker Calmann Cooper Ltd., London, 1977, and McGraw-Hill Book Company, New York, 1977.

Nocturnal Insects

Many species of moths and other very colorful insects fly at night when they are safe from birds and other predators. The only way to find and photograph them in a natural-appearing habitat is to attract and trap them, and place them in a prepared environment. This may take a small amount of research for each species you trap, but as you become familiar with the various orders and families, this will not be much of a burden.

In a rural or suburban area, the best way to trap nocturnal insects is to place a fluorescent or "cool" white light (an

UV light is ideal) next to a white sheet hung vertically from a tree limb or set of stanchions, and let the sheet funnel itself into a box on the ground. Several hours after sunset, the box will be filled with many specimens worth photographing simply for their color and design, if for no other reason. Another way is to bait tree trunks with a mixture of beer, molasses, and rotting fruit, especially bananas. When I first heard of this method I worried about making images of insects with red noses, but the beer just slows them down enough to photograph them on a nice tree trunk background.

Diurnal Insects

Diurnal insects and caterpillars may be captured by one of several methods:

- Non-flying insects may be simply scooped up and placed in a simulated environment. An "ant farm" may be bought from a commercial source, or may be easily built using a frame structure slightly separating two pieces of glass and filling the space with sand.
- Butterflies may be caught by stalking them with a cotton net (nylon nets increase the chances of damaging the butterfly's wings) and placing them in a terrarium for the brief time needed to photograph them. If you plan to keep them long enough for them to lay eggs, you should supply them with fresh flowers and a 10 percent solution of sugar and distilled water. Additional research will be required.
- Shaking a bush or small tree will cause many insects and caterpillars to fall to the ground. Simply place a large white sheet on the ground under the bush or tree, then shake it and watch the creatures fill the sheet.
- An aspirator may be used for more selective acquisitions. An aspirator is a jar with two tubes emerging from its sealed top. The inlet tube is placed near the insect through which it is sucked into the jar. The suction tube leads from the jar to the operator's mouth. The end of the suction tube inside the jar is covered with gauze or screen so that you don't inadvertently inhale an insect.

Insect field guides are very useful to the insect photographer, but are primarily written for the collector. These guides advocate the use of a "killing jar," which should be ignored by the nature photographer. Although I don't have any qualms about swatting flies or slapping mosquitos, a dead insect loses its radiance of color, and certainly can't "perform" for you in the studio. With involvement in nature photography you will undoubtedly gain a respect and reverence for life and the balances of nature, and at the end of a photo session, return each creature to its environment.

Safety Precautions

There are people who work with bees and who do not get stung. The wise beekeeper, however, takes precautions. If you are photographing a beehive, it makes sense to wear protective clothing and netting. Any of the insects of the Hymenoptera group (which include the bumblebee, honeybee, wasp, black hornet, and yellow jacket) are the greatest source of danger. These insects cause more deaths in the United States each year than rattlesnake bites, and should not be taken lightly. Space does not permit a complete dissertation on safety precautions and remedies, but if you plan to photograph venomous insects, please consult the materials mentioned in the footnote, or your physician.*

Aside from that dim note, Hymenoptera are extremely interesting, and relatively easy subjects to photograph. They are usually found on beautiful backgrounds (blossoms and wildflowers of all kinds) and are usually so busily involved in their work that they can be approached easily without being frightened away.

*Tod Schmelpfenig and Linda Lindsey, *NOLS Wilderness First Aid* (National Outdoor Leadership School & Stackpole Books, 1991), page 213 Anaphylactic shock.

Colin Fletcher, *The Complete Walker III* (Knopf, 1994), page 563.

Part V

What to Do with all These Pictures

You have expressed yourself in the visual arts by immortally emblazoning your artistic concepts and images on emulsified celluloid. But now you feel compelled to show them to the rest of the world.

The opus magnum that you made of a lightning storm two years ago would look great in the slide show you are preparing for a presentation to an art director. It would look even better with a peregrine falcon in the foreground. First, you have to find both slides. With the help of a computer, you have the opportunity of further artistic expression. Then you may want to prepare a portfolio using the resulting image as a lead picture.

Whether you have aspirations of selling photo rights, publishing your own work, or simply preparing a terrific slide show, you need to have your images well organized, and your presentation polished. This is the business side of photography.

RED-TAILED HAWK *Buteo jamaicensis* A performing captive superimposed on a lightning background

PEREGRINE FALCON *Falco peregrinus anatum* A captive peregrine falcon superimposed on a lightning backgound

Chapter 13

Special Effects

In Defense of Image Manipulation

A nature photographer is both an artist and a photojournalist, i.e., we want to record on film both the beauty and the truth in nature. There are photographers who are photojournalists in the purest sense of the word, and believe that no photographic image should be altered under any circumstance. On the other side there are artists out there who will do anything for a buck.

Then there is the gray area of photographers who are willing to enhance color or remove an ugly twig that crosses the animal's leg, but not necessarily alter the "truth in nature" statement that the image is attempting to make. But where is the line drawn in that gray area that says this is no longer "truth"? When we cross that line, wherever it may be, we are not lying unless we try to pass it off as truth. We are, with artistic license, creating an "interpretation of nature" that may tell a better story than the straightforward photograph. Whether or not the final image does its job depends on the artist and the audience.

Although I have a strong sense of ethics I am more of an artist than a purist. In other words, the manipulation of images for creative purposes by mechanical or digital methods doesn't bother me. I've been doing it for years and I'll continue to do it. I follow one important rule: honesty in the caption.

Every image in this book and most publications printed today have been put through a computer at least once for the purpose of making color separations or halftone screening. Some have undergone slight color correction or density/contrast adjustment. This low level of manipulation is the equivalent of using a polarizing filter or fill-in flash on the camera. The gray area of manipulation begins when we start to remove obstacles from the composition that we couldn't remove from the actual scene.

The images in this chapter are all manipulated past the "line" in the gray area. Some manipulations are meant to be obvious. Some are meant to appear believable but not "believed" to be the "truth in nature." All are meant to illustrate a medium and a method of creativity.

ZOOM MANIPULATION Explosion: start with the widest angle zoom setting and begin zooming in at the instant you release the shutter. For midday bright sun exposures, this will be still too fast a shutter speed to control the zoom effect. In this situation, add heavy neutral density filtration to attain a shutter speed of $\frac{1}{2}$ sec or more.

In-Camera Manipulation

The first and most simple tools of manipulative creativity can be done right in the camera with a zoom lens or a split-image filter/lens that mounts on the filter thread of your lens.

Zoom Manipulation

Try zooming back and forth with any zoom lens on your subject to visualize the end result. Practice with a few zooms to predict the timing of the slowest possible exposure. Then with the zoom lens locked firmly in position on a sturdy tripod, and the aperture set on the smallest f/stop, check the meter to determine the slowest possible shutter speed. For midday bright sun exposures, this will be still too fast a shutter speed to control the zoom effect. In this situation, add heavy neutral density filtration to attain a shutter speed of $\frac{1}{2}$ sec or more.

Now you may choose to simulate an explosion or an implosion. For an explosion, start with the widest angle zoom setting and begin zooming in at the instant you release the shutter. Zoom in to the narrowest angle for one-third the shutter speed duration so that a substantial portion of the exposure (two-thirds of the shutter speed duration) is at the maximum zoom position. For an implosion effect, follow the same procedure, reversing the zoom so that most of the exposure is at the widest angle position.

Split-Image Lenses

Split-image lenses mount on the filter threads of a normal lens. They come in radial and linear splits. While they are tools of creativity and have their place in producing special effects, they are limited to "one image per slide show." A second or third image in the same show can become conspicuously repetitious. Use them cautiously.

Lab Manipulation

Simple Color and Density Adjustments

An otherwise perfect slide is underexposed and too dark. It may be salvaged to a presentable state just by making a duplicate slide and overexposing the duplicate. It may even pick up some

contrast and be enhanced at the same time. (Note: An overexposed original slide may be made slightly darker but not with as much success as the aforementioned underexposure.) Or, something went wrong and the slide has a green cast to it. Simply make a duplicate slide and add some magenta filtration.

For this kind of work you can have a lab do it for you, or you can do it yourself and have much better control over the end result. I make my own duplicates using a Beseler Dual-Mode Slide Duplicator with Ektachrome Slide Duplicating film. Mount your camera body on the top end of the bellows and a short-mount lens on the other end of the bellows. You are taking a picture of a slide, so you are using the principles of macrophotography with 1:1 magnification (see Chapter 10—Basics of Macrophotography) The system uses its own color filtration, and allows you to dial in any color correction using the three primary colors: cyan, magenta, and yellow. A little bit of experimenting is necessary to establish a "filter pack" (the slight color filtration needed to match the color of the original) and an f/ stop for your standard exposure. Once established, you view the slide through the camera and dial in the color that pleases. Then add your previously established "filter pack" as additional filtration.

Sandwich Slides

Once you have become familiar with a slide duplicator the door will be opened to a great creative tool. A sandwich slide is made by putting two slides together in the same mount and making a duplicate of the combination. It works well with two slightly overexposed slides with complimentary subject matter such as a pastoral scene and a pale sunset. You can use correctly exposed slides but you must add exposure when making the duplicate to compensate for the density. You may want to start thinking in terms of pictures to take that will work well as sandwich slides such as cloud formations, patterns, or silhouettes of geese flying in formation.

Photomontage

Placing two images in one frame may be done either in camera or in the lab. Both demand precise planning and calcula-

EARTHSCAPE I This familiar NASA photo of the earth was superimposed on a sunset landscape taken at Organpipe National Monument, Lukeville, Arizona.

tion, but the in-camera method must be right the first time. In the lab using the slide copier you won't get first generation exposure quality, but you will have unlimited opportunities to obtain the perfect combination of exposures in the final composite.

To get two or more images on one frame of film, the area in which you are exposing the image should, ideally, be previously unexposed. If that area was partially exposed by a previous or subsequent exposure, the black or dark shadow areas will be compromised and contrast will be lost. At times this is desirable, at least through part of the area as in the "Earthscape II" example. The "Earthscape I" example illustrates a more purified double exposure. In this example the sky area was dodged (light held back with a black card) to keep it unexposed. To

EARTHSCAPE II Here the exposed area of the sunset lightened the lower part of the earth image. Sunset landscape taken at Organpipe National Monument, Lukeville, Arizona.

expose the earth portion of the composite, I cut a circular hole in a black card and held it slightly above the earth slide and kept it in motion during the exposure. This was done in a completely darkened room so that no light was reflected from the card it-self. The black card kept any "gray" light out of the second exposure (the earth exposure) and the motion prevented a hard edge from the card.

In the "Skull" example a combination of techniques was used. Duplicate transparencies were made for each of the four components. The critical areas such as the eye areas of the skull and the owl's outer face were blackened with a black grease pencil.

SKULL WITH GREAT HORNED OWL
The four components of this image are: 1. A Byzantine period skull taken on an archaeological assignment in the Middle East.. 2. The eyes of a great horned owl *Bubo virginianus*. 3. A detail from a forest fire landscape. 4. A lightning landscape that is turned upside down and feathered into the skull.

Computer Imaging

Keep one thing in mind as you read this section: between the time this book went to press and now, most likely the information has become obsolete! But so what, the ideas are applicable to whatever the up-to-date software offers.

If you don't have access to a computer that has graphics capabilities, you can rent time at a service bureau at a reasonable hourly rate. Most service bureaus offer the Macintosh system with several types of scanners and Adobe Photoshop™ software. This is really all you need to get started. The basics of

the Photoshop™ program are very easy to learn, and once you have mastered the basics, the creative special effects capabilities of the program are almost endless. I mention Photoshop™ here because it is the most popular software program among photographers and graphic designers. There are others on the market for both the Macintosh and PC that will do as well. But because of its popularity, several independent publishers have released books on how to get the best out of the Photoshop software. If you are renting time at a service bureau you should buy a copy of the book and study the techniques and methods of operation between sessions and at the computer.

Work with low resolution (lo-res) images while you are learning. Working on high resolution (hi-res) images, even on a fast computer, can be time consuming. With a hi-res image (300 dpi) each operation seems to take forever to finish and come back ready for the next stage. Then, if it isn't quite right you have to "undo" and try again, and perhaps again after that until you get that miserable message on the screen that says "out of memory." Lo-res images give you the same image on the screen while viewing a full frame (72 dpi is a standard CRT resolution even when viewing hi-res images) and have less bytes to redraw, and therefore take less time.

I like to think of the lo-res images as my "thumbnail" sketches. I will start a session by making hi-res scans of each component image. Then, using Photoshop™, I make copies of them in lo-res, and use them to make a quick composite. If the composite is as good as I imagined, I go back and repeat only the correct steps, this time using the hi-res scans. I've done all my trial-and-error work quickly in lo-res, and now know the most efficient direction to my finished product.

By the way, once the computer bug has bitten, you may find yourself taking pictures especially for scanning and merging with other images. The creative opportunities are endless.

ORGANIZATION Filing slides can be a time-consuming and exhausting job, but the results of keeping your files up to date can mean a quick sale if you can locate the right picture in a hurry.

Chapter 14

Presenting and Storing Your Work

In the early 1970s I was doing some freelance production work and commercial photography on the premises of a major publishing company. They were kind enough to give me a cubical of space to use for the indefinite time that I would be working on their projects. I immediately decorated my space and the surroundings with a few of my 16 x 20-inch prints from a recent gallery show. There were a lot of positive responses, and soon one of the department's managers asked me if I had any more. Of course, I had the rest of the show and wound up hanging about thirty large prints around the building. This, in turn, led to art directors and designers from all divisions of the company coming to me for many stock photos and assignments. I was constantly asked for advice about which cameras to buy and how to get this or that kind of effect in a photo. This led to giving mini-seminars to some of my co-workers during lunch time and after hours. Then one day an editor from another publishing company saw these photos while visiting the building. He asked if I would be interested in writing a book on

photography. I ultimately had five books published with the publisher he represented. My career was enhanced more than 1,000 percent. The moral of this story is: it pays to advertise. If you have an opportunity to hang some prints or give a slide show, do it—even if you do it for free. Give your work as much exposure as possible (no pun intended). Eventually, someone with influence and a use for it will see it and good things will happen.

Selling Stock Photos in a Competitive Market

If you have aspirations of selling your work, prepare yourself for the attack. You are entering an extremely competitive field. Yes, the market is hungry for good images. Yes, the picture that fits the best is the one that gets published. But, photo research departments send out their "want lists" and 150 photographers may respond with 200 great looking slides per photographer. Now imagine a photo researcher going through 30,000 slides to pick out one for publication. Any group of slides that don't have good caption material such as taxonomical descriptions of the species in the picture may be put aside for possible viewing—later on, if needed. Any images that are not razor sharp are out the window. Larger formats (6 x 7-cm or 4 x 5-inch) in attractive mats and cases may be viewed first. A name that is recognized may have a positive psychological influence even though it is no guarantee of a sale. What usually happens is images that are the best and most appropriate for the publication are pulled and the rest are returned to the photographer. If the pickings are good in the beginning of the pick session, the researcher will go through the rest of the pile quickly to see if anything "pops out" as excellent and appropriate. So, unless you have an irresistible collection of super-excellent 35mm slides with a mousetrap connected to the one you think is most appropriate, your submission may receive very light treatment.

Making Your Stock Submission Stand Out

Submit your images promptly. Of the thousands of calls that I've received from photo researchers over the years, I can count on the fingers of one hand the requests that were not super-

rush. Also, if your images are the first ones seen there is a better chance of getting some of them pulled for a final review. There is also a better chance of being noticed if your images are larger than 35mm. Many photographers are submitting 70mm duplicates of their best slides. They are large enough to be noticed without a loupe and they are affordable. Sending duplicates is also a lot safer than putting your originals at risk. In the past, photo researchers would accept nothing less than originals, but because of the present better quality of duplicates in the larger formats, that requirement is no longer strictly adhered to. If I want my best image to stand out among the pile of super excellent images submitted by other photographers, I send a 4 x 5-inch or 5 x 7-inch duplicate transparency matted in an 8 x 10-inch black card. These dupes are too expensive for any but the most worthy slides, the opus magnums. The bulk of the work has to be sent as 35mm originals unless you elect to make the larger 70mm dupes.

Use the standard top-loading plastic loose-leaf sheets to hold and send your slides. They accommodate 20 slides each. If you have 18 excellent 35mm slides, don't add two more mediocre slides to fill out the sheet. If you have only one appropriate slide that you think is a winner, submit only that slide in the center of the plastic sheet. Similar plastic sheets are available for 70mm and 6 x 6-cm transparencies. Submit only your very best for any "want list." If it is close to appropriate, it's not appropriate enough—don't send it. If it's beautiful but a little less than razor sharp, don't send it. If you are unsure of your own objectivity, get a second opinion from whoever is standing around. He or she does not have to be an expert to give a valid response. Use clean mounts. Each of your images should have a complete and neatly printed caption, an identification number, and your name in the form of a copyright line. Some publishers will send you their guidelines for stock photo submissions upon request.

Organization and Storage of Slides

Now that you have all these slides, what do you do with them? Without some organization, finding a slide that you made

several years ago can be chaotic and time consuming. If an art director calls for an original image that you showed duplicates of three months ago, you may have to get your hands on it and get it out by an express service or carrier pigeon by 8:00 PM that night. You need a filing system.

If you are familiar with computer data base systems such as dBase IV™, you can write your own filing system with cross-references. There are systems available for filing and labeling of slides, but they are constraining. So, until your files become unwieldy, use a manual filing system. Better and less costly methods may become available.

I use both computer and manual methods. Every slide is entered in a data base that gives it a number automatically. I assign it to a main category (the main essence of the image), and several subcategories (e.g., season, habitat, geographical location), and location of the slide itself (drawer or binder). The slide is then physically filed in a drawer or loose-leaf binder according to the main category of the image. Very often, I skip the computer and go directly to the slide itself.

A want list may read ". . . robin at nest feeding young. Must be in suburban residential northern New Jersey . . ." Because I once lived in northern New Jersey, I would go to the binder labeled "Passerines" (perching birds) and go to the section divider labeled "R" and find at least one page of robins. There would be the slide I remembered taking in Mendham, New Jersey, in 1975. The caption reads Robin *Turdis migratorius* at nest feeding young—Mendham, NJ Copyright ©1975 Milton Heiberg.

If I had gone to the computer first, I would have found the slide in the same place of course, but I might have found several others that I had forgotten about filed within picture stories in another binder under perhaps geographical location: New Jersey—Birds in northern New Jersey. I would have seen the caption for each, and flagged the entries that were most appropriate for the researcher. The printed list of slides is a record of what is being sent out to the researcher or publisher. A copy accompanies the slides and a copy is posted on my bulletin board where it will stay until all of the slides are returned.

The Portfolio

Wouldn't it be nice to be a featured photographer in a national magazine, or to be awarded an assignment to do a wildlife picture story of a particular species or habitat, or have an art director so impressed with your work that you receive a call for a remembered image in your portfolio? To make this kind of lasting impression you need not just a great collection of images, but also a great presentation.

For various reasons both practical and preferential, many art directors prefer to view a portfolio of 8 x 10-inch or 11 x 14-inch color prints, tear sheets, or other reflective art in a book form. It is easier and quicker to view, and the images may be seen in a form closer to that of the final usage. However, I prefer to show my work in a form cropped from 4 x 5-inch or 8 x 10-inch transparencies mounted on 11 x 14-inch black cards. I buy blank black cards (not the ones that have pre-cut 4 x 5-inch windows) from an art supply store and cut my own windows to the exact crop that I want to present. My reasons for not adhering to convention are:

1. Transparencies look better than prints simply because of the vibrancy of the light coming through the image. Duplicate transparencies are only one generation away from the original, and most of the quality of the original slide is maintained or even enhanced. They are also very close in quality and style to the final product that I intend to deliver. On the other hand, color prints (type "C" prints) require an internegative and, therefore, are two generations away. They are more difficult to produce and accurately maintain color and tonal quality of the original, and are subject to a lab technician's interpretation. Reversal prints (type "R" and Cibachrome™ prints) gain contrast and in many cases require masking (a process that holds back contrast). Labs find it easier to make a good 4 x 5-inch dupe than a good color print. At most labs these dupes are also less expensive than prints. If you feel adventurous, you can make them yourself with a color enlarger and some Ektachrome duplicating sheet film.

2. The oversized black card isolates the image from any surrounding visual interference that might compete for the viewer's attention. Chances are that the art director will open your portfolio and hold the first transparency up to the ceiling light. Even this amount of extra attention is better than having that art director flip quickly through a loose-leaf binder of prints and tear sheets. The ideal situation is to have your images viewed on a light box where they will get a closer and more critical look with 100 percent attention and appreciation.

3. As for showing tear sheets, although they do add a note of credibility to your presentation and they show that you can handle an assignment, you are depending on how well a graphic designer and a printing company either enhanced or misused your work. If a photo of mine has been used in a credible way, I will make a 35mm copy-stand slide of the tear sheet, cut a small (24 x 36-mm) window in the black card that holds the presentation dupe, and mount the slide film to it. This way the art director sees how the photo was used, but does not see it large enough to be distracted by criticizing or admiring the graphic design (possibly his or her favorite subject) and will concentrate more on the larger image in the center of the card.

One personal interview with an art director is worth ten portfolio drop-offs. Try your best to get one before settling for a drop-off. If you must drop off your portfolio, that's better than nothing, but be sure of a few things: (1) Your name and logo must be on every piece in the portfolio. (The handy little gold or silver self-adhesive address labels are wonderful.) One piece could be pulled to show someone else in the company or agency, and you don't want to lose it forever. You also want your name and logo repeated as often as possible. (2) The case that holds your portfolio should be neat, clean, and also have your name and logo on it. (3) Follow up with a phone call. Get the art director on the line personally and ask for an evaluation. Bold? Yes! But it is a reminder of the viewing that could easily be forgotten. Even a good viewing can be misplaced in memory. (4) Then follow up with a promo card mailing—soon and often.

If you are fortunate enough to get a personal interview with the art director, then let that person conduct the interview. Although a salesman must sell him- or herself, a photographer is selling photography. Let the images do the selling. I'm not saying neglect the charm. I'm saying when someone is looking at your portfolio in your presence, don't oversell the images, don't defend any criticism the viewer may voice. It can only work against you. The viewer may not have a negative attitude about your work, but may just be trying to call your attention to something you should be aware of, and feel that your work is very worthy of such attention. Until you know for sure, remain silent even if it hurts, unless you have a valid question about such criticism. It is better to "bite the bullet" and listen to the criticism than to risk sounding defensive and have that open dialog end. Besides, the picture must speak for itself—there are no excuses!

Upon leaving an interview, leave a promo card. Before the next day has ended, send a letter saying "Thank you for viewing. . . " Thereafter, frequent promo mailings are in order.

Matting and Framing

Let the images be the decoration, and let the mats or frames be beautiful, complimentary, but simple. The primary function of a frame or mat should be to separate the image from surrounding objects that may distract the viewer's attention.

The Slide Show

Organizing a slide show is a very subjective matter. It's your story. The actual mechanics of the presentation must consider keeping the interest of the audience. Grab their interest and hold it throughout the entire show. For the same reasons mentioned in the previous section for a portfolio, show only your best work.

With a slide show you have slides, frames in the proportions of 3:2 for horizontals and 2:3 proportions for verticals. Don't be limited to showing all your visual efforts within these constraints. Free yourself by cropping the slide itself. Start by

making a duplicate slide of anything you consider worthy of publication. By now that should include every slide in the show. Then crop the slide by the method described in Fototip 12.

Have fun!

Additional Reading

Zuckerman, J. 1991. *The Professional Photographer's Guide to Shooting and Selling Nature & Wildlife Photos.* Cincinnati: Writer's Digest Books.

Brackman, H. 1984. *The Perfect Portfolio:* New York: Amphoto.

FOTOTIP 12

CROPPING SLIDES

Keeping the rules of composition in mind (see Chapter 4—Content, Lighting, and Composition, especially "leave out the unessential"), take a good hard look at the slide. If the unessential is still there—here's your chance to get rid of it.

MATERIALS

- Plastic slide mounts available at camera stores
- Chrome metallic tape or chrome vinyl tape (made by Prestype™ and Letraset™) available at art supply stores
- Light box, slide editing box, clean window, or any other improvised backlighting source
- Razor blade
- Lighter fluid or Kodak Film Cleaner
- Cotton cloth or cotton balls

PROCEDURES

1. Remove the slide from its mount by cutting the mount carefully with a razor blade along the base of the word "Kodachrome," "Ektachrome," or "Fujichrome" halfway through the cardboard. Then carefully break away the film from the cardboard at the spot of adhesive. Practice with some waste slides.
2. If the slide needs cleaning, clean it now while it is out of the mount. Use lighter fluid and a soft cotton cloth or a cotton ball. *Do not* use paper products of any kind including lens cleaning tissue.
3. With the emulsion side *down* tape the film loosely to a light box or the transparent surface of an improvised backlight source.
4. Using the chrome vinyl tape, mask out the unwanted areas of the picture. If you make a mistake, apply a drop of lighter fluid to the tape and it will lift off easily. Start again with a new piece of tape.
5. Trim the tape with a razor blade or scissors and remount the film in a new plastic mount.

Note: If the slide is a prized original (opus magnum), use only a duplicate for cropping and/or projection.

Index

Fototip 1
Sunny 16 Rule
1/ISO = Shutter speed at f/16 in mid-day bright sun.
—See page 31.

Fototip 2
Guide Numbers of Flash Units
Guide number/feet = f/stop.
—See page 37.

Fototip 3
Fill-in Flash
Set the aperture for the flash—then compensate the shutter speed for the ambient background.
—See page 38.

Fototip 4
Evaluating a Photograph
Content—Point of interest, lighting, form, composition, point of view.
—See page 50.

Fototip 5
The Scheimflug Principle
(Simplified)
The plane created by the lens board of a view camera, when tilted, will form a new plane of focus from the point where it intersects with the focal plane.
—See page 60.

Fototip 6
To Photograph Lightning at Night
1. Set aperture at f/8.
2. Focus at infinity.
3. Set shutter speed dial at B.
4. Aim camera at direction of anticipated lightning.
5. Hold shutter open until lightning strikes.
6. Close shutter, redirect camera as storm moves, advance film and repeat procedure.
—See page 63.